smart phone
smart photography

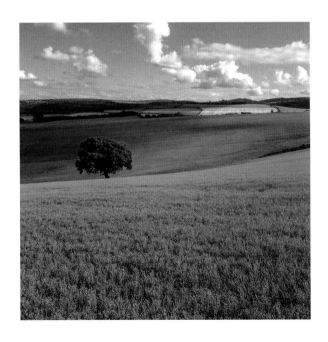

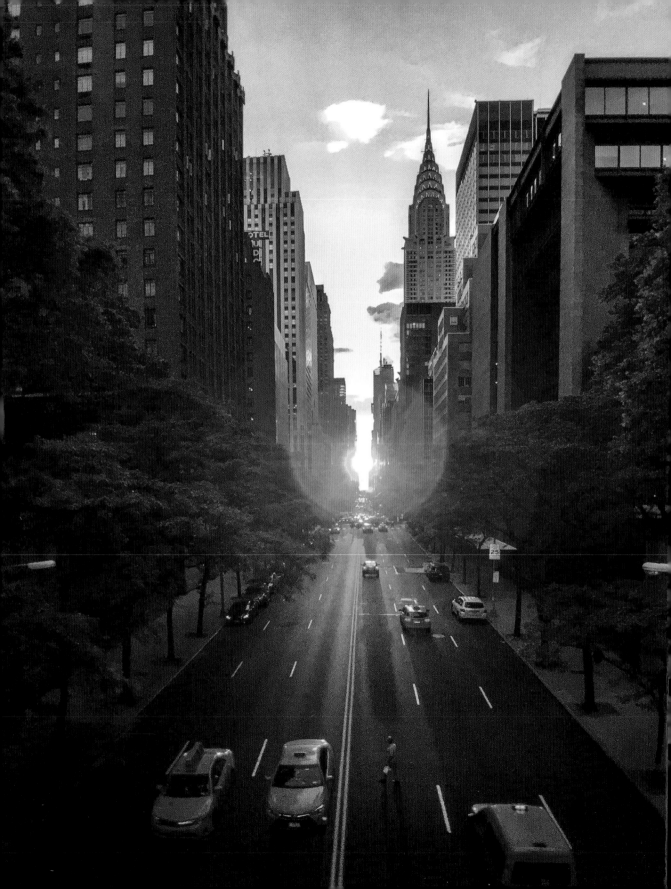

Jo Bradford

smart phone
smart photography

Simple techniques for taking incredible
pictures with iPhone and Android

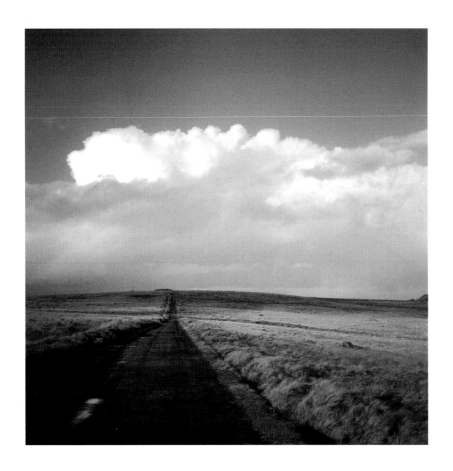

CICO BOOKS
LONDON NEW YORK

Published in 2018 by CICO Books
An imprint of Ryland Peters & Small Ltd
20–21 Jockey's Fields 341 E 116th St
London WC1R 4BW New York, NY 10029

www.rylandpeters.com

10 9 8 7 6 5 4

Text, photography, and illustration
© Jo Bradford 2018
Design © CICO Books 2018

A CIP catalog record for this book is available from
the Library of Congress and the British Library.

ISBN: 978 1 78249 562 8

Printed in China

Photographer: Jo Bradford
Editor: Nathan Joyce
Designer: Paul Tilby

Commissioning editor: Pete Jorgensen
In-house designer: Kerry Lewis
Art director: Sally Powell
Production controller: David Hearn
Publishing manager: Penny Craig
Publisher: Cindy Richards

ABOUT THE AUTHOR

Jo Bradford is a practicing artist and
photographer. Having graduated from
University College Falmouth with a master's
degree with distinction in photography, Jo
now offers tuition and group workshops in
smartphone photography and image
editing. Jo also travels widely for public
speaking engagements and to participate in
seminars about photography. Jo's Instagram
profile @greenislandstudios, where she
exhibits her smartphone photography, has
over 40,000 followers and was featured on
the popular BBC television show *Countryfile*.
She is based in Dartmoor National Park,
Devon, UK.

To my little darlings, Grace and Kade, without whose endless love and interest this book may well have been finished sooner. And to Paul, for putting up with me.

CONTENTS

Foreword

Throughout this book, you will find simple instructions for both iPhone and Android devices, giving you all the skills you need to get the most from your camera. I have taken all the photos in this book on smartphones, using an iPhone 6s and an HTC U11.

I have also included suggestions for composition and subject matter, and provided food for thought about a life made richer through the making and sharing of photographs.

I firmly believe that the key to taking a good photograph has far more to do with understanding how to use your camera, and has far less to do with having all the most expensive kit. Everybody has access to a digital camera on their smartphone. So, even if you have got all the gear, but no idea how to tap into its potential, that's about to change! You are about to make an investment in your creativity by taking the time to learn how to use your camera's basic functions. While the smartphone camera itself may not be as dazzling as a large-format camera system, the processor that your phone's camera can harness is nothing short of amazing. Best of all, the skills required to make great photos with your smartphone are quick and super-easy to learn. You will be amazed at how intuitive your device's camera is, so get to know your new best friend and it will pay back dividends every day.

Feel free to dip into the sections of this book that interest you most, and look out for the tips and exercises that will help you learn by doing. It always works for me to try things for myself, so I hope it will for you too. I only ask that you invest the time in yourself to read and digest the first section that covers the nuts and bolts of photography; this will set you up to use your camera with gleeful abandon, taking pictures with skill and purpose. And let's be honest, who doesn't love a bit of gleeful abandon—go on, treat yourself!

Consider this: when I drove to the shops today I didn't think about how to drive the car, because I've got those skills dialed in. My mind was free to think about the journey and enjoy the sights as I went along. I didn't once concern myself with the technicalities of how to change gear or speed up and slow down, because I know how to do those things subconsciously. This book should help you get to the same place with your smartphone camera too; soon the operational aspect will be almost subliminal, leaving you free to enjoy the journey and to capture the views as you go. My aim is to make you so comfortable with the technology that you can be free to explore your own unique voice and style.

I must confess that in the past, I have been something of a camera snob. If I could time-travel back five years and tell myself that I would soon be selling off many of my DSLR cameras in favor of taking photos with just a smartphone, the younger version of me would be flabbergasted. But here I am and this is how that sea-change happened...

While on maternity leave after having two children in quick succession (well it seemed like a

good idea at the time), I wanted a chance to do something creative for five minutes every day amid the all-consuming world of new motherhood.
I decided to take a new photo of the National Park where I live every day for a year and post them daily to Instagram in a project called "A Love Letter to Dartmoor in 365 Photos."

Trekking around Dartmoor carrying my three-month-old son and my 23-month-old daughter, along with all their kit, meant that my hands were full. I had to be adequately prepared in an area renowned for rapid changes in weather. Keeping us warm, dry, and fed for even a few hours on the moor required an extraordinary amount of supplies. I couldn't carry my DSLR camera and lenses around with me too. But my iPhone was always at hand, so I shot all the photos on that. It turned out to be a life-changing decision to ditch my DSLR, but I found that focusing on just the fundamentals honed my skills significantly. With no zoom lens or aperture to adjust, I had to get creative to solve the issues posed by the tiny camera lens and sensor, using light and shade as I found it, and moving closer to things instead of zooming in. When the project concluded, I exhibited the photos at the Dartmoor National Park Visitor Centre, and seeing how well the images printed was a revelation.

To a certain extent, photography involves being in the right place at the right time, but it really helps if you already know where the right places are and when the right time is likely to be. Make your own luck, do your research, try new things, tune your

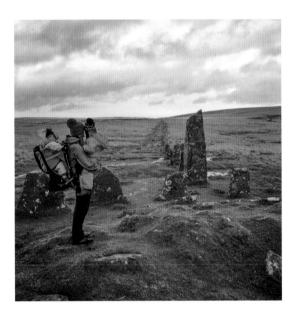

subconscious into watching the light. Always keep your eyes open for photo opportunities and they will frequently present themselves to you as your reward.

If you read all the way to the end of this, thank you—you're obviously one of the good ones!

Enjoy,

Jo

MOTIVATIONS AND INSPIRATIONS

PHOTOGRAPHY IS A HEADY MIX OF COURAGE, KNOWLEDGE, LUCK, RULE BREAKING, CHANCE, AND HAVING CONVICTION IN YOUR OWN IDEAS. MOST OF ALL IT'S ABOUT LEARNING TO TRUST YOUR INSTINCTS AND BEING WILLING TO TRY NEW THINGS; FAILURES ARE JUST STEPPING STONES TO SUCCESS, SO DON'T BE AFRAID OF GOING THROUGH A FEW ON YOUR JOURNEY TO GET THERE.

THE BIG PICTURE

Let's take a look at the big picture for a second. All forms of photography are basically about the same set of skills, regardless of the camera with which you capture the scene.

The skills involved include knowing how your camera works and understanding a few key concepts, such as focus, exposure, ISO speed, and composition. Don't worry—this is all simple stuff. Your phone camera isn't overloaded with bewildering dials and expensive technology; it is simple and intuitive to use. You are going to be able to see something, shoot it, share it, and move on. No hassle, no fuss.

DAILY PHOTO PROJECTS

If I learned one thing from doing a 365-photo project, it is that taking a picture every day of the year makes you a better photographer. Practice makes perfect, and you will learn and find solutions in ways you never imagined possible. A daily photo project will teach you how to really see, and finding out how to do this is the most important thing you will discover on your photographic journey. You will learn to trust your instincts about what makes a good photograph. This is how you will find your own voice and start to make the pictures that sum up who you are. You are what you take, you are what you share, and you are what you feel. Keep this all in the back of your mind as you progress. Shoot what makes you feel happy and gives you pleasure to look at afterward. Enjoy the experience, do it just for you, and the rest will follow.

EMOTIONAL RESPONSE

I live in a place with big skies; it is full of drama with lots of clouds, rain, and fast-moving storms. This type of environment can make us feel small and wholly insignificant in the face of dominating weather systems that we humans have no control over. It can be intimidating, overwhelming, and exhilarating to be out in the weather; it fosters an emotional

response, and that is what I try to share in my images. Do you have feelings (good, bad, or indifferent!) about where you live? Try to make images that express what you feel. Striving for this kind of honesty is going to improve your photos significantly. When taking your pictures, take some time to think about how the light, the views, and the mood of the place are making you feel. Now you are tapping into true creativity; you are producing uniquely honest, emotional pictures, so keep at it—it only gets better.

PLEASURE FROM PURPOSE

Photographic vision—the art of seeing photographically—means that you have to learn the possibilities and limitations of your equipment and come up with strategies to allow you to get what you want from the kit you have at hand. This is never truer than when you are working with your smartphone. The kit may be limited in some ways, but there are plenty of creative solutions to help you overcome this. It won't make you happy to point your camera at something, fire off a few shots without much thought, and then feel disappointed that you are not capturing the same scene your eye sees. I like to think about making photos rather than taking them. Whether you subscribe to mindfulness as a philosophy or not, there is a lot to be said for being in the moment and giving yourself the time to do things well and with purpose. Slow down, think about what you are trying to achieve with the photo, and think about how to use your tools to do it. Choose the exposure that works for you instead of the one suggested by the camera software, and frame your chosen subject in a way that communicates something. This is the moment when you stop waiting for good images to appear before your very eyes; this is the moment you take control. Your photography will improve immeasurably if you afford it the honor of your full attention because this is when you stop taking photos and start making them.

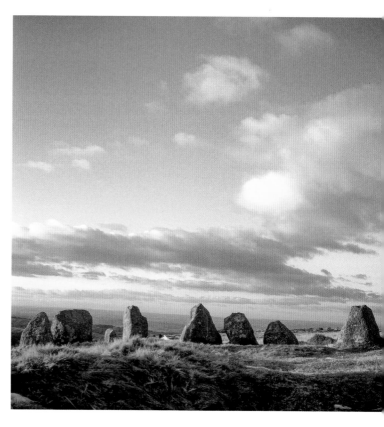

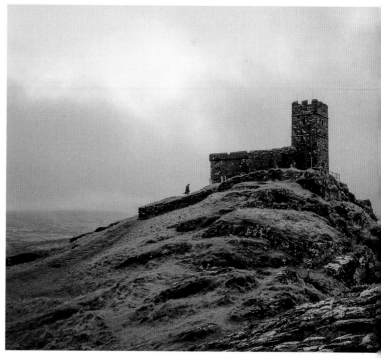

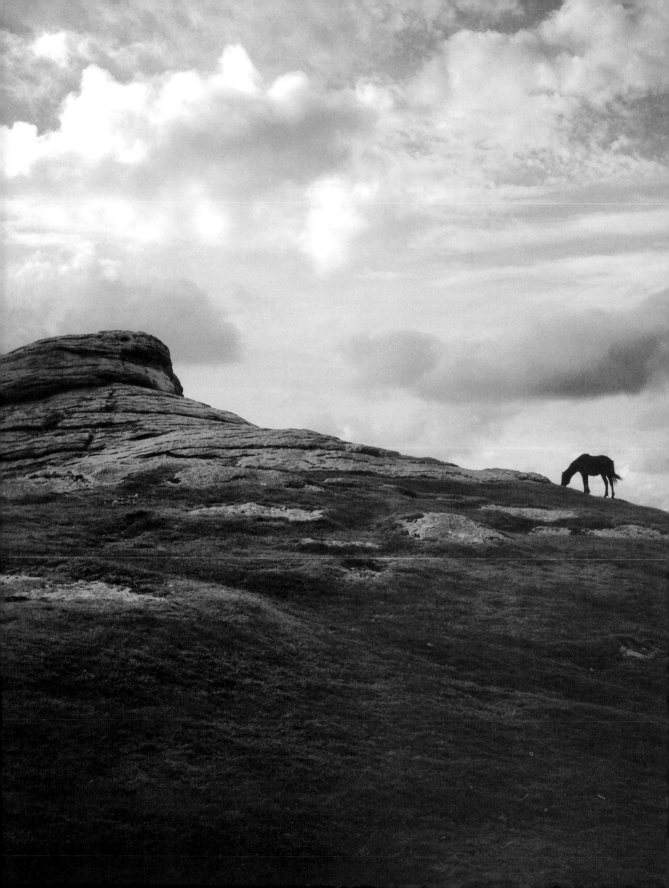

PHOTOGRAPHY: THE BIG PICTURE

1

1

FOCUS AND COMPOSITION

IN THIS CHAPTER YOU WILL DISCOVER WHAT MAKES A PICTURE APPEALING AND LEARN SIMPLE METHODS TO ACHIEVE VISUAL HARMONY IN YOUR PHOTOGRAPHS. FOCUS IS THE SINGLE MOST IMPORTANT THING THAT WILL MAKE OR BREAK YOUR PICTURES, SO READ ON TO LEARN HOW TO FOCUS PERFECTLY EVERY TIME.

COMPOSITION

COMPOSING YOUR PHOTOGRAPH EFFECTIVELY MAKES THE DIFFERENCE BETWEEN A HASTY SNAP AND A PHOTO YOU WILL BE PROUD OF. IF YOU CAN PERFECT THE ART OF ARRANGING ALL THE ELEMENTS, YOU WILL END UP WITH A PLEASING, WELL-BALANCED RESULT THAT WILL ELEVATE YOUR PICTURES TO A NEW LEVEL.

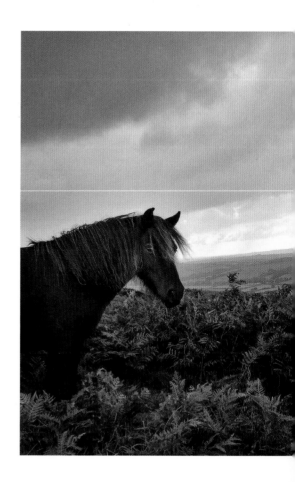

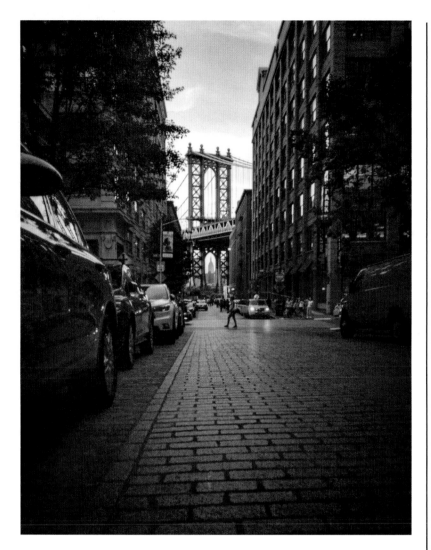

Think about the relationship between objects in the foreground and background. How does your subject relate to what is around them? Have they got a lamppost sprouting out of the top of their head? Is there a flowering bush growing out of their ear? Try to arrange the compositional elements in such a way that they don't overlap or overwhelm each other. Let each one speak for itself. Keep it clean and uncluttered.

COMPOSING WITH COLOR

Colors can be compositional elements in a big way. A splash of color from a small yellow umbrella will speak across the composition to a yellow cab elsewhere; the colors will create a dynamic all their own.

Remember that according to art theory, blue colors tend to recede in the frame and warm colors will come forward. Use this knowledge to help you compose with color.

RULE OF THIRDS

LET'S LOOK AT WHAT MAKES A GOOD PHOTOGRAPH. THERE ARE RULES FOR COMPOSITION AND BALANCE TO MAKE YOUR IMAGES VISUALLY APPEALING—USE THEM AS TOOLS, NOT RULES.

The rule of thirds is the best-known principle of composition in photography. This simple technique is considered by many to be the basis for making well-balanced, attractive photographs. The rule of thirds is a simplified version of an ancient principle known as the golden ratio. The golden ratio (approximately 1:1.6) was arguably used by artists such as Leonardo da Vinci—his masterpiece *The Last Supper* includes a number of objects whose length and width appear to be in the golden ratio. If it was good enough for him, it's good enough for us. Let's look at how you can apply this simple idea to your pictures.

Imagine the photo you are taking is broken down into thirds horizontally and vertically. This means that the image has nine sections, broken up into three sections across and three sections down. There are four places where the lines of the grid cross (marked with a red X in the illustration opposite). These intersections are the ideal places to position your subject or point of interest. The four lines are useful guides for positioning the other elements of the picture. Various studies into this ancient concept have shown that when people look at a picture, their eyes do not look at the center first, but they are naturally drawn to one of the intersection points.

I have applied the grid to one of my photographs featuring a church on a hill; the church is situated along the vertical line on the right-hand side and sits squarely where the horizontal and vertical lines intersect.

MAKING INFORMED DECISIONS

Rules are made to be broken. Learn the rule, but be prepared to ignore it sometimes. You may find that you naturally place your subjects according to the rule of thirds without even thinking about it—or it may turn out that your subject suits a different composition altogether.

All that matters is that you understand the ideas of composition so that you can make informed decisions about when and where to apply them in your own work.

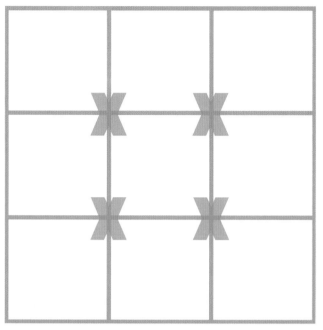

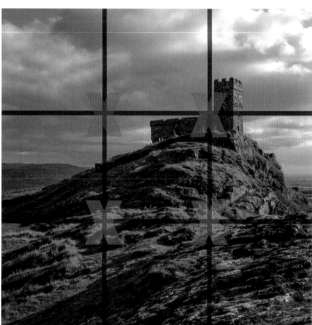

THE GRID

I use a grid overlay in my screen to help me frame a shot according to the rule of thirds. The grid will not only help you with composition, but it will also banish those wonky horizons and leaning buildings for good!

All smartphone cameras have a grid function; it can either be found within your camera's settings or within the general settings.

For an iPhone, go to the main Settings menu for your device. Scroll down to "Photos & Camera," scroll down to the "Camera" heading, and swipe the "Grid" button to the right to turn it on.

On Android phones, open the camera up, and swipe to the left to reveal several options. Open up the "Settings" option, and under the "General" tab you will find the option to turn your grid on.

Keep the grid on from this point; it will subconsciously train your eye and brain to reach new heights of perceptiveness!

FOCAL RANGE EXPERIMENT: WHAT YOUR DEVICE CAN DO

THE BEST WAY TO GET YOUR HEAD AROUND DEPTH OF FIELD IS TO GET YOUR CAMERA OUT AND HAVE A PLAY.

Explore how your camera reacts to foreground, background, and middle-ground depth of field by setting up a quick little test for it and taking three photos.

▶ Set up an object like a glass of water (or whatever is at hand) on a table or stool in front of a window, then put a vase or similar object nearby on the windowsill.

▶ Set your camera up so that you can see both objects in the frame without them overlapping and so you can see some of the scene outside the window too. With any luck you will see the hard line of a rooftop or something in the far distance (background) to test your sharpness on.

▶ Stand in the same place for all three photos. You can set up a tripod if you like, but this isn't necessary.

▶ First, take a photo by tapping on the screen so that you are focusing on the glass of water in the foreground.

▶ Then, without moving your camera, tap the screen to focus on the vase on the windowsill and take another photo. Finally, tap on the view outside the window to focus on the background and take a photo.

Now look at the three photos you took and see how the area of focus changes. All cameras vary, so the results will be similar but not identical from device to device; this shows you what yours is capable of.

Notice how shallow the focal range and depth of field are in the first image where the focus is on the glass of water and the middle and background is blurred.

In the second image, see how the focal plane extends when you focus on the middle ground. The foreground is probably not sharp now, but look at how much more of the frame is in focus in this photo.

In the third and final photo, you will notice that the focal range extends farther through the image, with everything in the middle to foreground looking sharp.

FOCUSING

When you take a photo, the camera guesses what you want it to focus on. It often thinks that you want it to focus on whatever is right in the center of the frame, but if you have been paying attention to your composition you might have your subject aligned on the rule of thirds grid (see page 15). So, it is important to take control of the focusing away from the camera and own it yourself.

Just tap on the area of the screen that you want to focus on and hey presto! The focal point will change to that spot. That covers anything that is not moving in your photo. But quite often things are moving and this presents a different problem, but one with an easy solution. Instead of just tapping the screen to focus, tap and hold your focal point until the AE/AF indicator comes on. This will lock the focus. Now if the focal point moves, the camera is tracking it and will keep it in focus. Clever, huh?

Note that focus has a close relationship with exposure, so ideally the area that is correctly exposed should be the focal point of the image as well. Correct exposure is covered in the section on the exposure triangle beginning on page 30.

ZOOMING IN

Many smartphones can only zoom digitally, and you should avoid using this feature at all costs, because it decreases image quality. Unlike optical (lens-based) zoom, which you will find on DSLR cameras, the digital zoom on a smartphone's computer is guessing at the extra pixels it will take to make your picture bigger or appear closer. The result will generally look degraded and fake. If zoom is a game changer for you, then you will be pleased to know that the newest generation of high-end devices have optical zoom features.

If you want to fill more of the frame with your subject, then either attach a telephoto lens, or get those feet moving and step closer. See the Kit List section on page 142 to read more about lens attachments.

DYNAMIC DIAGONALS

THIS IS A VERY EASY CONCEPT TO GET YOUR HEAD AROUND. WHEN THINKING ABOUT PLACING YOUR SUBJECTS IN THE FRAME, YOU SHOULD CONSIDER USING DIAGONALS.

There are six main elements of design: line, shape, form, texture, pattern, and color. The strongest of these elements is line. Diagonal lines evoke impressions of movement, which is why they are considered to be dynamic. Diagonal lines will help to define the space and guide the eye to the visual aspects of the scene.

According to the diagonal rule, important elements of the picture should be placed along diagonal lines. Diagonal lines give an image depth by suggesting perspective, and they are a simple, yet effective, way to breathe life and energy into a composition.

Once you have taken your first shots on pure instinct, stop and look for some leading lines and take another few shots. Try stepping to the left, leaning to the right, crouching down, sitting down, and lying down. Look at the lines each time you move and stop when you find the scene that has balance. This will train your creative brain to look for them next time without even thinking about it!

You will need to keep an eye out for those tricky horizontal and vertical lines, and make sure that they work with the framing of your image and not against it. A leading line that comes in from the bottom corner will work wonders for an otherwise static composition. When executed well, the leading line can act as foreground interest in its own right.

LEADING LINES

LEADING LINES DRAW YOU INTO THE SCENE, ACTING AS POINTERS TO WHAT YOU WANT THE VIEWER TO NOTICE. THEY PROVIDE COMPOSITIONAL STRUCTURE THAT LEADS THE EYE AROUND THE IMAGE, GIVING THE PHOTO DEPTH AND MAKING IT MORE DYNAMIC. LOOK FOR LINES THAT WILL LEAD INTO YOUR FRAME AND GUIDE THE EYE TOWARD THE SUBJECT. THEY MAY BE ON THE WALLS, IN THE SKY, OR ON THE FLOOR.

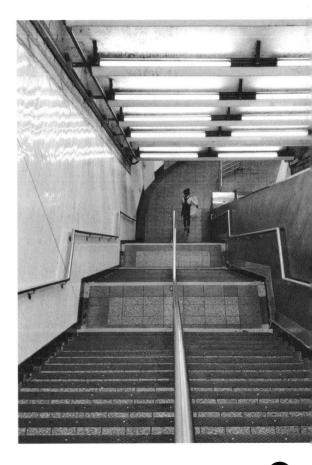

WORKING WITHOUT ZOOMING IN

ALTHOUGH A POWERFUL TOOL, ONE AREA WHERE MANY SMARTPHONE CAMERAS ARE FLAWED IS WITH THEIR INABILITY TO ZOOM OPTICALLY. THIS WEAKNESS CAN TURN INTO A STRENGTH WITH GOOD COMPOSITION.

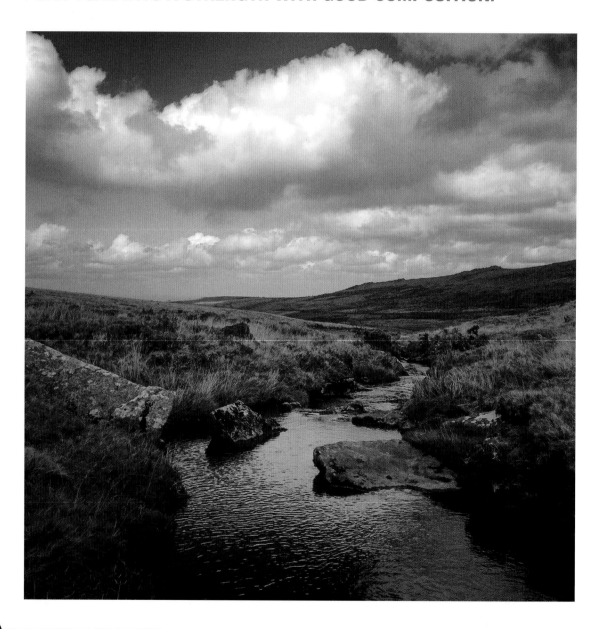

Working with your tiny smartphone camera lens, that distant mist-shrouded hill, rolling green valley, or quaint country cottage may be too far away to feature as the main subject in your image, but you can still include it if you have a leading line as foreground interest that sweeps through the picture and deposits the eye right there. Once you train your eye to look out for compositional gems, you will start to find them everywhere. Every small stream and bend in the road could be leading the eye to something interesting far off in the distance.

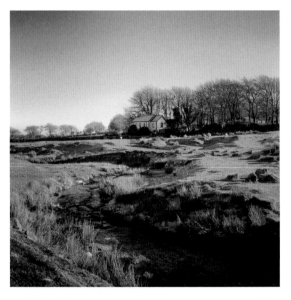

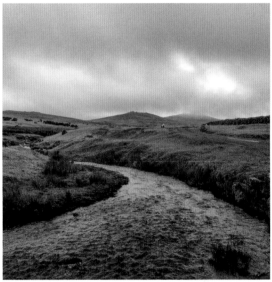

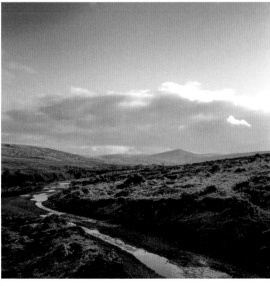

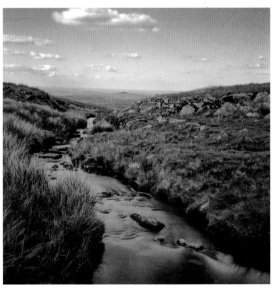

COMPOSING FOR BLACK AND WHITE

THERE IS A TIMELESSNESS TO BLACK-AND-WHITE PHOTOGRAPHY, A PARED-DOWN VISION OF A WORLD SEEN IN TONAL CONTRASTS AND SHADES OF GRAY.

Working in black and white is a great way to hone your compositional skills because it allows you to concentrate on line, shape, form, and texture.

Black-and-white landscapes rely heavily on a strong composition; reducing a photo to monochrome tones requires a good eye for a graphic composition. Pay attention to bold, interesting shapes, and look for leading lines and good light. Your image can be about nothing more than the quality and play of light and shade.

Give consideration to your focal point. This is a good time to try using silhouettes in your images. If you reduce your subject to a silhouette, do so where there is a strong variation in tonality between the subject and the background. Silhouettes work best with a shape that is easily recognized, such as a human form, an animal, or a tree. Expose for the bright background to throw your subject into silhouette. During the edit phase you will be able to use the Snapseed app to darken selective areas of the silhouette, if required. See The Editing Process and Snapseed on pages 130–131 for more about selective brightness adjustments.

Overcast skies become moody and brooding in black and white, so use this to your advantage and work in black and white on bad weather days. That said, I always shoot in color and edit the pictures into black and white with the VSCO app afterward.

Head over to my section on Editing with Apps to find out how I edit my photos into black and white using the VSCO app (see page 129).

ASPECT RATIO

Aspect ratio is the relationship between the width and the height of your image.

A square format image has an aspect ratio of 1:1 where both the width and height are the same.

Landscape photographers like the 4:3 aspect ratio (i.e. an image wider than it is tall), which is like the proportions of a large-format camera.

If you still hanker for the proportions of 35mm film photos, then the 3:2 aspect ratio (i.e. even wider than 4:3) is the one for you.

It's easy to alter aspect ratio to suit your own preferences, so check the options in your phone's settings.

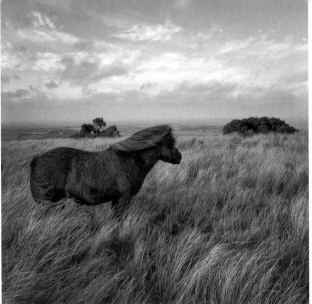

FORMATS

A LOT OF PEOPLE GOT USED TO SHOOTING FOR SQUARE FORMAT WHEN WORKING WITH SMARTPHONES BECAUSE INSTAGRAM USED TO PRESENT PHOTOS IN GRIDS OF SQUARE TILES. I STILL OFTEN FRAME UP IN A SQUARE FORMAT, POSSIBLY BECAUSE IT IS HABITUAL BUT PERHAPS ALSO BECAUSE IT OFTEN FEELS LIKE A NEAT WAY TO PRESENT AND FRAME AN IMAGE. I LIKE THE WAY THAT CIRCULAR AND SPIRAL COMPOSITIONS WORK SO WELL WITHIN A SQUARE FRAME, WHICH MAY BE PARTICULARLY INTERESTING TO PEOPLE SHOOTING IMAGES OF STAIRCASES, ARCHITECTURE DETAILS, PATTERNS IN NATURE, AND SO ON.

Landscape format is wider than it is tall and is well-suited to shooting wide landscape views. Its width naturally draws the eye to horizon lines. I like to position focal points near an edge of the frame to give the composition space. You will find that compositions based on the rule of thirds sit very nicely in a landscape format.

Portrait format is great for shooting people, as the name suggests. It follows the same sort of proportions as the human body, so it allows you to frame up easily for that kind of image-making. But there is more to the portrait format than meets the eye. I enjoy shooting landscapes in a portrait format where the image is taller than it is wide. This allows me to feature more of the big skies and astounding cloud structures that I am always drawn to. It also gives me the opportunity to include leading lines in the landscape that link the foreground neatly to the background, providing an enhanced sense of perspective.

SYMMETRY AND REFLECTIONS IN WATER

ANY BODY OF WATER HAS THE POTENTIAL TO PROVIDE A REFLECTION OF THE SKY ABOVE. THE WATER NEEDS TO BE STILL FOR THIS TO WORK PROPERLY, THOUGH. EVEN AN UNREMARKABLE PUDDLE CAN YIELD SURPRISING RESULTS IF YOU KNOW HOW TO USE IT.

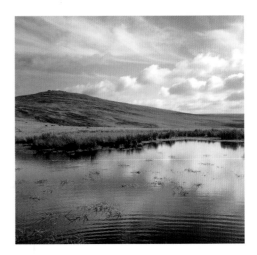

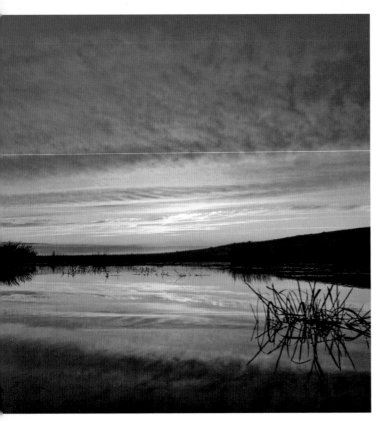

Crouch down to get closer to the water's surface, put your camera out above the water rather than at the edge of it, and hold your camera so that you are almost dipping your hand into the water—I'm sure I don't need to give you a safety warning here; common sense should prevail! You will immediately notice that the water's surface becomes a mirror for the landscape and light. I rarely walk away from these shots without soggy shoes, but crouching down low makes all the difference.

If you are shooting a lake and you want perfect symmetry, you simply have to line up the top of the water with the horizontal center of the frame and everything above and below it should be nicely symmetrical.

On some phones, you are able to adjust the camera's ISO (the sensitivity of your camera's sensor to light; the higher the setting, the more sensitive the camera is to light). Alternatively, you can use an app like Camera+ to adjust the ISO. Try setting it to ISO 100, which will stop the image from looking grainy or "noisy."

Play with your focal points: start by tapping to focus on the place where the water ends and the land begins. Check the photo to see if you are happy with the amount that has rendered sharp. If not, take more shots with slightly different focal points until you find the one that works best in your composition.

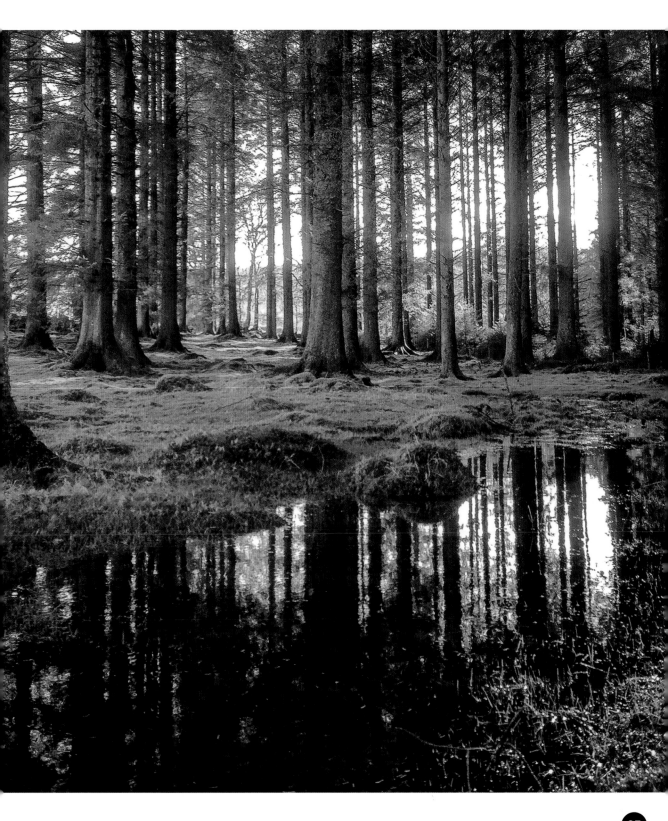

PANORAMAS

ULTRA-WIDE PANORAMA PHOTOS ARE A GREAT WAY TO MIX UP YOUR REPERTOIRE. A PHONE CREATES A PANORAMA BY STITCHING MULTIPLE IMAGES TOGETHER TO CREATE ONE SUPER-WIDE IMAGE. IN PANORAMA MODE, YOU CAN TAKE 240º PHOTOS IN A SINGLE IMAGE. THERE ARE APPS THAT ALLOW YOU TO SHOOT 360º PHOTOS TOO.

Strange though it may seem, you will need to hold your phone in portrait orientation rather than landscape to take a conventional horizontal panorama. Select panorama mode and you will see a guidance arrow in the center of the screen.

Expose for the bright area by tapping there on the screen. You can lock down your exposure (usually done as you tap to set exposure by pressing and holding the screen until the AE Lock sign comes on—the AF sign might come on, but don't worry about that now). This will avoid those exposure fluctuations that occur as the camera tries to adjust for the changing light conditions as you move toward or away from the position of the sun in your image.

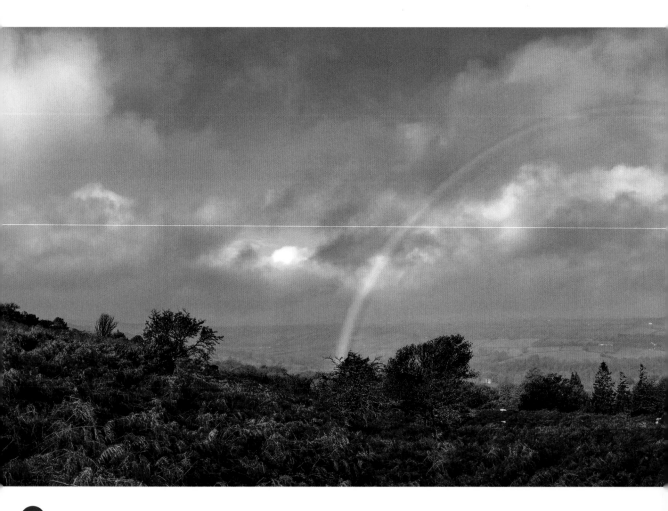

Find some shelter from strong wind because you will need to have a steady hand as you swivel around.

Perfect your stance: your feet should be shoulder-width apart and facing the center of the scene of your panorama. Keep your hips facing the center of the frame and your feet firmly planted, then swivel your upper body to the left or right.

Start your panorama and slowly swivel your upper body from the waist around to the middle and on smoothly to the far right of your panorama (start at the right and go left if you prefer). You may need to practice this a few times to perfect your speed, because if you go too fast, the camera won't be able to keep up!

Remember to hold the lens and screen level to keep your horizon straight.

Have a few goes until you get the hang of it in each location. I usually find that my first one doesn't look all that smooth but, practice always seems to make perfect, so write the first one off as a dummy run and try again!

Have you tried a vertical panorama yet? They're great for shooting tall buildings or for capturing somewhere with a decorative interior that runs from floor to ceiling. Hold your phone horizontally this time. Stand with your arms outstretched in front of you, lock your elbow out, and slowly arch your arms up and over your head. Remember to keep your arms stretched out the whole time.

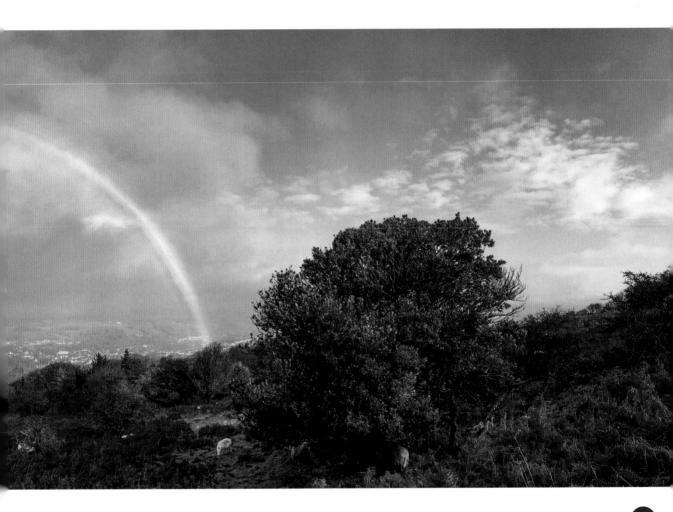

2 EXPOSURE

UNDERSTANDING EXPOSURE IS A SKILL THAT WILL ELEVATE YOUR PHOTOS TO THE NEXT LEVEL. KNOWING THE REASON WHY YOUR PICTURES COME OUT TOO LIGHT OR TOO DARK WILL GIVE YOU THE ABILITY TO MAKE PHOTOGRAPHS THAT MATCH THE VIEW THAT YOUR EYE SEES, SO READ ON TO BANISH THOSE DISAPPOINTINGLY DULL PHOTOS FOR EVER MORE.

GETTING THE LIGHT RIGHT: THE ART OF EXPOSURE

EXPOSURE IS THE ART OF GETTING THE BALANCE RIGHT BETWEEN LIGHT AND DARK IN A PHOTO. IT IS THE VITAL SKILL YOU NEED TO TURN THE VIEW YOU SEE AT THE TIME INTO THE SCENE YOU CAPTURE FOR POSTERITY.

Happily, exposure is super easy to manage on your smartphone camera screen—it just takes a tap and a swipe.

One of the big issues people experience when shooting with a smartphone camera is that it doesn't always manage the contrast between the highlights and the shadows as well as the eye does. Our brain is really good at this job and does it so much better than a camera. They are essentially doing the same job; they are both big sensors that interpret the light that comes through a lens, except that your camera's sensor is smaller and less gifted than your brain.

I think the sky is every bit as important as the landscape below; the way the clouds change the light on the landscape or are reflected in the glass of skyscrapers is an integral part of the scene in the moment of making that photo. I am an old-school photographer in that sense. I like to see cloud-highlight detail recorded faithfully, and I prefer pictures where the bright parts aren't completely white with no detail (also referred to as "blown out" or overexposed). The land always references the sky above, so for me it's important to have both sky and land equally represented.

PRO-LEVEL SKILLS

TO TAKE YOUR SMARTPHONE PHOTOGRAPHY TO THE NEXT LEVEL, YOU CAN OVER-RIDE THE BASIC NATIVE CAMERA IN YOUR DEVICE TO TAKE MANUAL CONTROL OF THE SETTINGS, UNLOCKING ITS POTENTIAL TO PERFORM MORE INTELLIGENTLY. DON'T PANIC IF THIS SOUNDS TOO TECHNICAL, THE NEXT FEW PAGES WILL REVEAL ALL.

MANUAL iPHONE CONTROL WITH PROCAMERA

For the iPhone I use the ProCamera App among others. Worth investing in alone for its ability to save your photos as uncompressed RAW and TIFF files, it enables you to make bigger, better photos for printing and sharing. (To learn more about File Types, Files Sizes, and Compression, turn to page 139, and for more about Prints on Paper, see page 136.)

Another great tool in the ProCamera App's armory is the ability to set the focal and exposure points in the same place or to pinch them apart, so that you can set a focal point in one place and expose for the brightest area separately. This can then be locked off, with just a tap and a press.

There is the option to choose between auto, full manual, and shutter priority or ISO priority mode in the ProCamera settings. I recommend that you shoot with ISO priority selected, because it gives you a simple workflow that begins with setting the ISO value, then looking at the available shutter speeds, and going on from there to set the exposure compensation. Note that there is more about ISO on pages 36–37.

The obvious exception to this workflow is if you want to shoot action scenes and freeze movement, when it works best to select a fast shutter speed. Tap the shutter speed figure at the top of the screen to activate the shutter priority setting. From here you can set yourself a fast shutter speed and let the app adjust the ISO to match the shutter speed you

have selected. You can then make your own fine adjustments to the exposure by touching the E/V (exposure value) symbol (usually in the top center of your screen) to adjust the exposure manually to + or - 7. Try to keep that ISO as low as possible to avoid noise (see page 38 for more information about Noise).

Don't forget to turn your grid view on in the settings. I prefer to work with the "rule of thirds" grid, which is usually labeled with the number 9, to represent the number of squares in the grid. See page 15 for more about using grids.

MANUAL ANDROID CONTROL WITH PRO MODE

You can easily control the latest Android devices with the Pro Mode, which is accessible in the camera settings.

Access the Pro Mode by swiping down on the = symbol on the main camera screen to reveal the settings menu.

The latest generation of Androids, such as the HTC U11, shoot RAW files in Pro Mode (for more about RAW files, see JPEG, TIFF, and RAW File Formats on page 141).

In Pro Mode you will find individual sliders that allow you to make adjustments to your ISO, shutter speed, focal range, and exposure compensation, among other things. To work in shutter priority mode, tap the Auto button at the top of each slider to turn the feature on and off.

THE 3 SIDES OF THE EXPOSURE TRIANGLE

WHEN YOU PRESS THE SHUTTER BUTTON, IT OPENS A LITTLE CURTAIN BEHIND THE LENS SO THAT LIGHT FALLS ON A SENSOR IN THE CAMERA. THIS IS WHAT CREATES THE PHOTO.

The process of allowing light into the camera involves three key functions that all work together:

SHUTTER SPEED
The amount of time the shutter stays open to let light hit the sensor is called Shutter Speed.

APERTURE
The size of the hole that opens to let the light in when the shutter is pressed is known as the Aperture.

ISO
You can alter the sensitivity of the sensor to let more or less light in when the shutter opens depending on how bright the shooting conditions are. This sliding scale is referred to as the ISO value.

SHUTTER SPEED
Seconds of exposure time

1/3 1/30 1/60 1/125 1/250 1/500 1/1000 1/2000 1/4000

APERTURE
Size of lens opening

f22 f16 f11 f8 f5.6 f4 f2.2 f2 f1.7 f1

EXPOSURE TRIANGLE

25 50 100 125 160 200 250 320 400 800 1600 2000

ISO
Light sensitivity

EXPOSURE EXERCISE

Get to know your smartphone camera's dynamic range by practicing on high-contrast scenes to test your camera's capabilities.

You will need a scene with bright white areas and deep shadows, which you will find aplenty at noon on a sunny day.

▶ Tap to expose (and focus) on the bright white area, ideally a white wall or car, and take your first photo.

▶ Next, tap on the sky to expose for that and take a photo.

▶ Thirdly, tap on a mid-tone area (go for grass or brickwork that is in direct sunlight), and take another photo.

▶ Next, tap to expose for a mid-tone area again; this time, it needs to be out of direct sunlight but not in deep shadow. When you're ready, take a fourth photo.

▶ Finally, take a fifth photo, exposing for the deep shadow area of the image.

Now look at these photos, zoom into them, and find the image that has retained the most detail across all the areas of the image. Once identified, this gives you a guide for exposing the scene. You will almost certainly still need to make some tweaks to the exposure in an editing app, but this exercise will have provided valuable information about your camera's abilities with exposure.

DYNAMIC RANGE

THIS IS SIMPLY THE RANGE OF HIGHLIGHT AND SHADOW DETAIL THAT CAN BE CAPTURED BY A CAMERA.

Smartphone cameras have a fairly limited dynamic range. You will notice that in high-contrast scenes when you push your exposure up to illuminate your subject better, you end up with white, blown-out highlights that do not contain any detail at all.

Loss of detail occurs in your pictures when the range of exposure values in your image exceeds the capabilities of the camera. It is what happens when your camera cannot handle exposing the bright sky and the shadows evenly, resulting in either dark blocked-out shadows or overly bright "blown-out" skies. You can solve this problem by exposing for the highlights, making sure that they aren't blown out and have lots of detail. The rest of the picture will come out darker, but this can be an easy thing to fix with an app afterward. Don't let the dark areas get

so dark that you either can't see any detail at all in them or the detail you can see is really grainy—as this is not an easy fix without trading off some image quality elsewhere. It's better to have balance between the loss of detail in the highlights and in the shadows.

Ideally, try to manage a high-contrast image at the time of shooting. Make your adjustments there and then, knowing that working within the limitations of the smartphone means accepting that sometimes the camera alone cannot do the job. Instead of avoiding shooting photos that have more dynamic range than your camera can handle, just learn how to balance what you have in front of you and how to use the editing apps to fix the rest later. See pages 126–35 of the Editing with Apps section for details on how to fix exposure and dynamic range issues.

SHUTTER SPEED

AS YOU ALREADY KNOW, THE SHUTTER IS THE LITTLE "CURTAIN" THAT OPENS BRIEFLY TO LET LIGHT IN WHEN YOU PRESS THE BUTTON TO TAKE A PHOTO (TECHNICALLY THE BUTTON IS CALLED A "SHUTTER RELEASE"). HOW LONG IT STAYS OPEN FOR IS WHAT WE REFER TO WHEN WE TALK ABOUT SHUTTER SPEEDS. THEREFORE SHUTTER SPEEDS ARE LINKED WITH TIME.

Shutter speeds can be long or short depending on the conditions. A fast shutter speed can stop time in its tracks and a slow one can seem to stretch time out.

So, as a rule of thumb, when it is bright and sunny you will need a faster shutter speed, to avoid letting too much of that bright light in. When it is dark, you will need a slower shutter speed to allow the shutter to stay open longer and let lots more light in. A good all-round shutter speed on a sunny day is 1/125s.

SHUTTER SPEED TIPS

Shutter speeds are measured in fractions of seconds, so 1/30s is one thirtieth of a second. A super-fast shutter speed is something around the 1/4000s mark—that's one four thousandth of a second: lightning fast! Fast shutter speeds can capture a racecar speeding along, a horse galloping, or a sportsperson doing what they do best. These are movements that are usually impossible to discern precisely with the naked eye, but your shutter, with its ability to freeze motion, can give them a whole new perspective.

The slow shutter speeds that allow you to take long exposure photos which will last for two seconds, or even 30 seconds or more, are written like this: 1" or 30". Slow shutter speeds let a lot more light in, so while the shutter is open, it will also record all the movement that happens in the viewfinder during that period of time. This will allow you to capture and blur movement, so that cascading waterfalls become smooth, silky, white sheets, and the lights of moving cars become trails of red and white.

A point to bear in mind here is that sometimes the camera will try to set a shutter speed which is too slow for the conditions. When shutter speeds are too slow, it is simply impossible to hold the camera still for the length of time that the shutter is open; the rhythms of your heart beat and breathing will make the camera shake and you will get blurry photos. Make sure that the shutter speed is not slower than 1/60s to prevent this. Ideally, a shutter speed of 1/125s will be fast enough to avoid any camera shake. If you want to use a shutter speed slower than 1/60s, to keep the image sharp put your camera on a tripod. If you don't own a tripod, I strongly suggest that you invest in one: it's an essential tool for every photographer. If you can't stretch to buying one right away, then you can make do with resting your camera on a steady surface such as a table or a stack of sturdy books.

OVER SATURATION

Smartphones have a tendency to deliver over-saturated images, which can look distinctly fake. It is simple enough to deal with, though. Snapseed, Instagram, and VSCO all feature a saturation adjustment setting in the editing tools. Try turning the saturation down a tiny amount and see how it instantly makes images look more realistic.

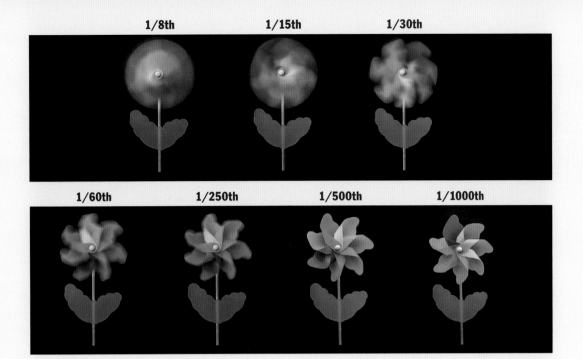

1/8th **1/15th** **1/30th**

1/60th **1/250th** **1/500th** **1/1000th**

SHUTTER SPEED EXPERIMENT

The way to understand how the shutter speed affects the camera is to play with it. Do this by taking the same picture but adjusting your shutter speed settings each time.

Whether you are shooting in Pro Mode on Android or using an app like ProCamera on your iPhone, set your ISO value to 100. Don't let your camera adjust the ISO value during this exercise—keep it at 100 ISO to highlight just the effect from the variations in shutter speed. Start at the slow end of the shutter speed slider—it will have a whole number on it (for example 32 seconds). Take a photo and move the slider a small way along, then take another picture at this slightly faster shutter speed. You will soon be working with speeds that are shown as fractions of seconds (for example 1/30 of a second). Work along the slider and snap pictures at each shutter speed until you get to super-fast shutter speeds like 1/8000 of a second. One of the first things you notice when you review the images is that the faster the shutter speed, the darker your image is.

You will see that some of the photos are lovely and sharp, while some are blurry. Notice the point in the exercise where the pictures start to blur. This is the point when hand-holding is no longer stable enough for the shutter speed; this will usually be around the 1/60s, but if you have a camera that is good at handling low light, it may be closer to 1/20s. You will also be able to see the effect the shutter speed has on how light or dark your image is.

Now, try putting your camera on a tripod to photograph the slower shutter speeds and see what a difference it makes to the sharpness of your photos when you are shooting below 1/60s.

You should now understand the relationship between the shutter speed and the brightness of your image. You will be able to see that you only need the shutter to be open for a tiny fraction of a second to let light in, but the longer it is open, the more light gets in and the brighter the image is.

Don't expect to be a master after one session, but if you practice shooting in this mode and make your own creative decisions about the amount of focus and light you want in your pictures, before long you will be turning out some great shots and you will know exactly how you achieved them. Then you'll know it was worth the effort you took to learn this cool new skill!

BURST MODE

IF YOU HAVE EVER SEEN A PRO PHOTOGRAPHER AT WORK YOU MAY HAVE NOTICED THAT THEY OFTEN TAKE CONTINUOUS SHOTS AT HIGH SPEED. THIS GIVES THEM THE OPPORTUNITY TO SELECT THE BEST FRAME LATER.

You have a continuous shooting feature on your smartphone called burst mode. Portraits aside, it is also a good way to work when you are trying to capture and freeze action.

For the example opposite, I overlaid all the photos in the burst into one image so that I could illustrate just how much of the motion detail you can capture when shooting in burst mode. This makes for a pretty weird image though, so there is another one below which has just five of the frames selected and overlaid.

Never miss that definitive moment again! Just press and hold the shutter button down, instead of tapping it once the way you usually take a photo.

When you see the burst images in your camera roll they will appear as a single image, but there will be a number in the photo's edge to tell you how many frames are in the burst. You can choose the "select" option in your photo album to go through the set of burst frames and just keep a few of them. I used Photoshop to overlay the frames in these examples, in case you're wondering!

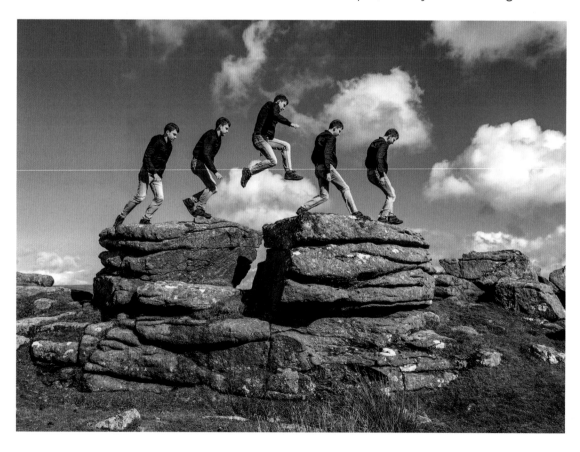

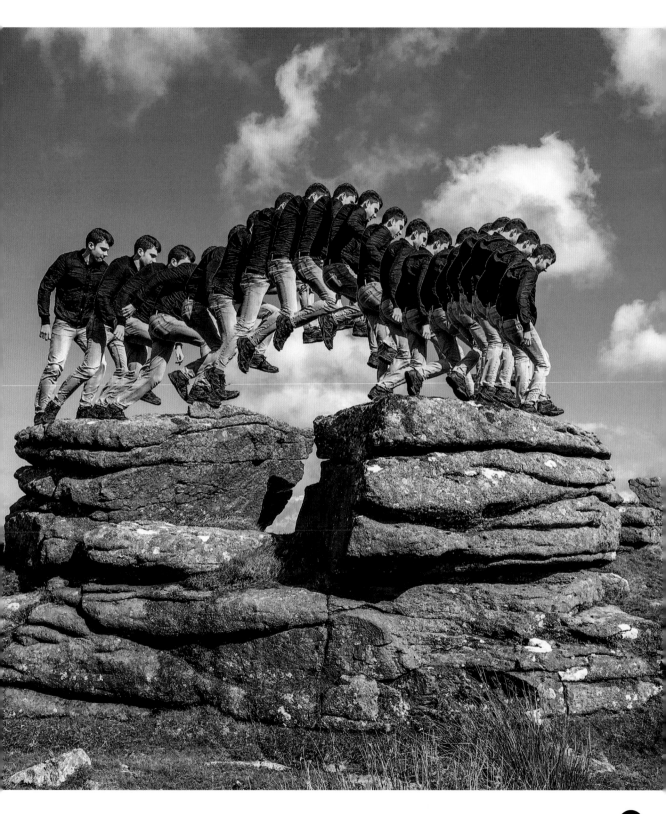

ISO

ISO STANDS FOR INTERNATIONAL STANDARDS ORGANIZATION, AND IT IS A SCALE FOR MEASURING SENSITIVITY TO LIGHT.

Adjusting your camera's ISO value (rather than relying on automatic mode) lets you set its sensitivity to the light conditions, and this will allow you to get a lot more out of your camera. In the good old days, ISO originally referred to the speed of the film. The idea is to keep your ISO value as low as possible at all times, because although smartphones have clever algorithms for noise reduction these days, some are more effective than others, and the higher the ISO, the more the image will be affected by digital noise.

The higher the ISO number you select, the lower the amount of light you need to be able to shoot in. If you are shooting in bright light, you will need to set it to a slower speed like ISO 50 or ISO 125. If you set your camera to a low ISO, for example ISO 100, the resulting photograph will be better quality than one set at ISO 1600, because the trade-off for being able to shoot in low light is increased noise and grain on the image.

Another way to look at ISO is the way it can be used to manage shutter speed. If you want to be able to use a very fast shutter speed, you will need to gather the light into your image in a very short space of time. Therefore your camera will need to be highly receptive to light.

So, to freeze the movement of someone running past you, you will need a fast shutter speed. Start by setting the shutter speed needed to freeze the action, anything from 1/500th of a second or faster. Now, starting with your ISO at the lowest setting—ISO 100 or lower if possible—keep raising it incrementally until you get to the point when the screen isn't too dark to see anything. If it is a well-lit scene, aim for an ISO well below ISO 800; anything over this ISO and the amount of digital noise in the image becomes an issue.

Here's how to alter the ISO on your smartphone:

iPHONE

Open an advanced camera control app such as ProCamera (see page 29 for more about manual control with ProCamera) and set the mode to ISO priority.

▶ Note the current ISO is shown at the top right of the screen.

▶ Using the ISO sensitivity changer, which appears as a plus (+) or minus (-) setting on the bottom right of the screen, take the ISO down to ISO 25.

▶ When you change the exposure, you will see a marker move along the little guide toward the -7 or +7 values.

▶ On the top right of the screen, you will see the shutter speed, shown as a fraction, for example 1/80s. This shutter speed value will change as you adjust the exposure (as explained previously).

▶ There is a great ISO range available on the ProCamera app—from ISO 25 up to ISO 2000—to work with.

ANDROID

On an Android device, the range of ISO values available to you is around ISO 100 to ISO 800. To access your ISO settings, you will need to open up the Pro Mode (see page 29 for more about this) in your camera settings to alter your ISO.

▶ Swipe out the menu which is denoted by = on the main camera screen.

▶ In Pro Mode, slide the ISO slider left, as low as it will go. Most Androids go down to around ISO 100.

▶ Adjust the shutter speed slider until it is bright enough to see the scene on your screen, making sure your highlights aren't blown out.

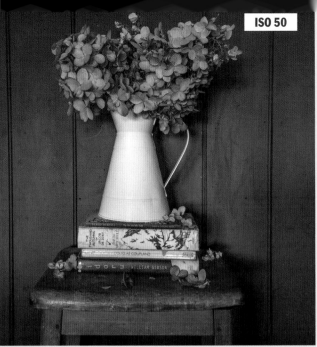

ISO 50

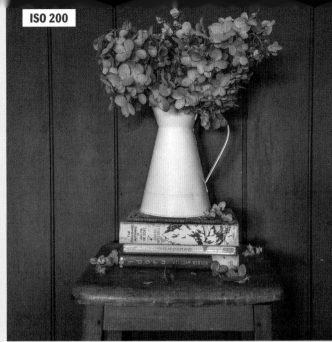

ISO 200

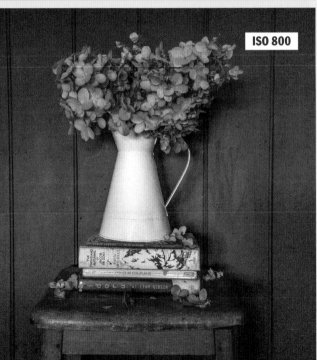

ISO 800

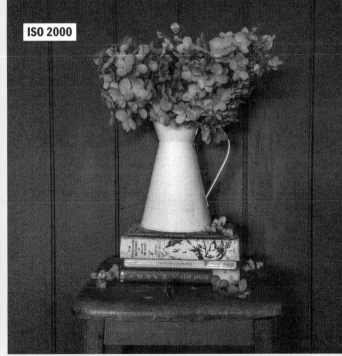

ISO 2000

WHAT ISO TO USE WHEN

▶ ISO 50 to 200 is ideal for a bright sunny day.

▶ ISO 200 to 400 is a good range to shoot with on cloudy days or when the light is beginning to fade.

▶ ISO 400 to 800 is best for indoor shooting.

▶ ISO 800 and above is necessary for darker scenes and night-time shooting.

NOISE

Shooting in low light is when you will test your smartphone's capabilities to the limits. You can push your ISO setting to a high number to allow hand-holding (as opposed to using a tripod) in very low light, which is a remarkable feat in itself. But this comes with a price… noise. (The previous page shows the difference in the amount of noise present when shooting the same scene using four different ISO values.)

Noise appears when an area of the scene is so dark that only a minuscule number of photons of light hit the sensor. In this instance, the camera is not getting enough accurate image information to form a clear picture, so noise appears as a by-product of this sampling error. Noise is most notable in a dark area with smooth continuous tones such as a blank wall or a blue sky.

The higher your ISO setting, the more noise you will have. To manage it, try to keep the ISO setting as low as possible. Tripods are your best friend in this situation; they allow you to use a very low ISO for the conditions and you will be able to avoid noise almost entirely. To try some very low-light photography, maybe in the blue hour, iPhone users can use a low-light app such as Slow Shutter Cam that has amazing noise management algorithms. On Android I shoot RAW files (a file format that captures all image data recorded by the camera's sensor when you take a photo) in the camera's Pro Mode, and then adjust the noise in an app like Adobe Lightroom afterward. Android users can also try the Manual Camera app.

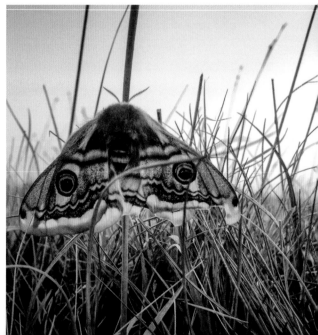

WHY YOU SHOULDN'T BE INTIMIDATED BY TECHNOLOGY

One of the big issues people experience with a smartphone camera is that it doesn't always manage the contrast between the highlights and the shadows as well as our eye does. This results in a shot with dark shadows or bright skies, which differs from the view our eyes are seeing.

When you think about it, our heads are just like big cameras. Our brain is a big sensor that interprets the light that comes through the lens in our eyes, in much the same way as the camera lens and sensor relationship works. More so, the pupils in our eyes, or apertures—see where I am going with this?—let the light in by expanding and contracting to suit the brightness of the room, just like the aperture size can be changed in a camera lens to suit the brightness of the conditions.

At this stage in our technological advancement, our brains are much more powerful processors and much better at interpretation than any digital sensor; therein lies the disconnect between what we see and experience compared to what a camera sees and records with its relatively unsophisticated lens and sensor. That's why you need to be able to use your big brain to tell the camera's tiny brain what you want it to do—you're the more intelligent one in the partnership—don't underestimate yourself. And that, in a nutshell, is why there's no reason to be intimidated by technology!

HIGH-DYNAMIC-RANGE IMAGING (HDR)

HDR is a matter of personal taste and I will leave it up to you, but I am not a fan so I always turn off the setting (tap the HDR symbol to toggle the feature on and off). Arguably, there are times when this function works very well, but conversely it can also ruin a picture. HDR processing works by finding hard edges in the image to transition from one exposure state to the next. This is fine when you have an image with everything in sharp focus, but it fails if some of the image is soft or out of focus—you end up with weird hard lines and halos which ruin your image.

If you use HDR at the point of image capture, you cannot get rid of it later, so it is better to learn how to use apps in the editing stage to get that contrasty, punchy effect. This way, you can make the same improvements, but everything is under your control.

DEPTH OF FIELD AND APERTURE

DEPTH OF FIELD IS THE ZONE IN WHICH OBJECTS FROM NEAR TO FAR ARE IN FOCUS IN YOUR PHOTOGRAPH.

A wide depth of field is where everything in the picture is in focus, so objects in the foreground, the middle ground, and the background are all equally sharp. A shallow depth of field is when only a foreground area is in focus and everything else around it is artfully out of focus. We need to know about depth of field because it is what helps claim a sense of space in our images. It is also about what is sharp and what is not. See the section on Focusing on page 17 for more about this.

We assign numbers to help us understand the focal range of the aperture (i.e. how much of the image is in focus). This number is preceded by an "f," which stands for focal range. Most smartphones have a lens aperture of around f/1.7 to f2.2. A large f-number denotes that a large area of the image is in focus and a small f-number means a small area of the image is in focus. It is as simple as that. So an aperture of f/2 is going to have shallow focal range, whereas an aperture of f22 will mean that most of the image from foreground to background is sharp.

Working with a smartphone camera (which uses a fixed-aperture, fairly wide-angle lens), you will notice that the depth of field will extend the farthest when you are focusing on something far away, so this works well for landscape photography. If you choose something in the middle ground, you will see that almost everything beyond it will be fairly sharp too, allowing you to capture much of the scene in sharp relief. When you shoot something close to the lens, you will notice that only a small area of the picture in the foreground is sharp (a shallow depth of field). Go to the section on Still-life Shooting and Depth of Field on pages 112–13 for more about the practicalities of creating depth of field on a smartphone. When shooting landscapes, it never hurts to try a few shots where you make something in the foreground the focus of the image and let the background recede gently out of focus in a way that is both pleasing to the eye and makes the most of the limitations of a smartphone lens.

You can add additional lenses to change the depth of field. For more on the different types of lenses, see pages 44–45.

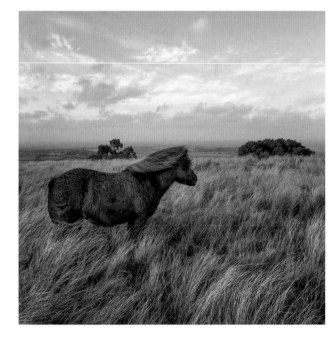

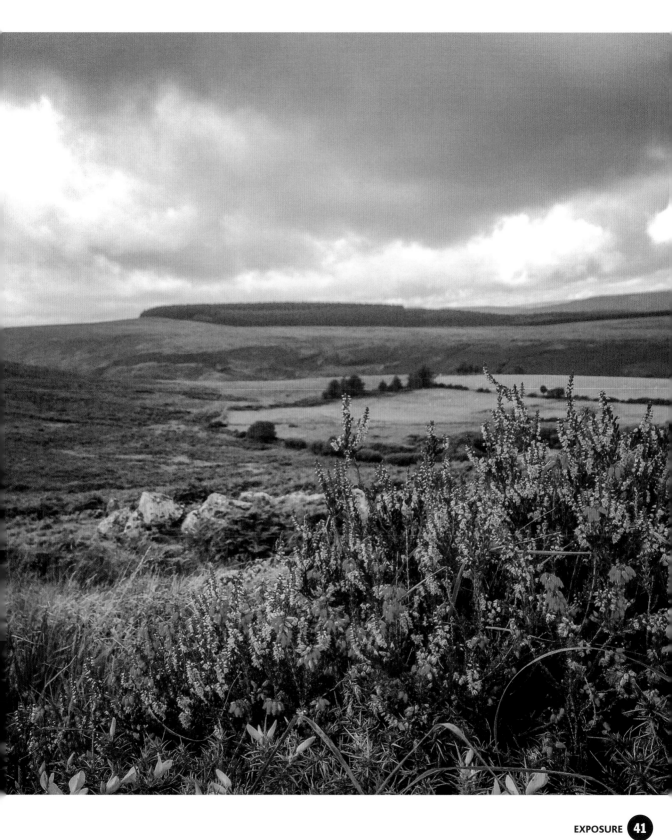

PHOTOGRAPHY IS LIGHT

HERE YOU WILL FIND SIMPLE EXPLANATIONS AND IDEAS TO MAKE SENSE OF THE WAY LIGHT AFFECTS A PHOTO. AS PHOTOGRAPHS ARE NOTHING MORE THAN THE RECORD OF LIGHT THAT YOUR CAMERA SAW WHEN YOU TOOK THE PHOTO, IT WILL MAKE A HUGE DIFFERENCE TO YOUR PICTURES IF YOU GET YOUR HEAD AROUND HOW TO USE LIGHT. ONCE YOU HAVE READ THIS CHAPTER YOU WILL HAVE ALL THE KNOWLEDGE YOU NEED TO MAKE INCREDIBLE PHOTOS TIME AFTER TIME.

CHAPTER 3 LESSON 1

LIGHT IS THE KEY

LIGHT IS THE KEY COMPONENT OF PHOTOGRAPHY; WITHOUT IT PHOTOGRAPHY COULD NOT EXIST. LEARNING TO RECOGNIZE GOOD LIGHT AND HOW TO USE IT IS A FUNDAMENTAL SKILL IN PHOTOGRAPHY.

Great photographers develop a keen understanding about the potential light has to affect the images they make. It will alter the mood and set the scene, but the image-maker has to be receptive to it first, to allow it to work its magic in their images. Once you become aware of light's presence and absence in the frame, you can use it as a compositional tool and employ it to shape and define the subject. The spectacle and thrill of capturing the light centers on the relationship between what is in the light and what is in the shade; both halves of the puzzle must fit together for that wow factor to emerge in your images.

Light is the most important thing on my list when I am making a picture. I watch it constantly, and I react to its whims with total commitment. I plan to return to places where I have seen it make a show. I anticipate its next move and wait with bated breath for it to deliver.

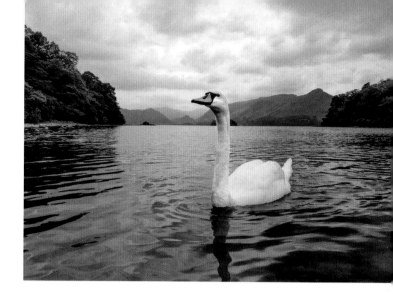

LENSES AND LIGHT GATHERING

LIGHT GATHERING IS WHAT PHOTOGRAPHY IS REALLY ALL ABOUT.

One of the reasons why you will see the size of your smartphone lens aperture mentioned prominently in the blurb about your device is that it is a key feature for image quality, and as such, it is the area where the manufacturers are looking to make gains and brag about them! For more on Depth of Field and Aperture, see page 40.

Smartphones generally have a fixed aperture. The iPhone 6s has an aperture of f/2.2, while the iPhone 7 and 8 feature apertures of f/1.8. The Android device I use is the HTC U11, which has a fantastic lens aperture of f/1.7.

The smaller the f-number, the faster the lens, and fast lenses give you better low-light images, with less noise and blur. So the good news is that the lovely wide apertures of smartphone lenses get a big thumbs-up.

So how best do you work with the lens in your phone? Well, foreground interest must always be a consideration. Since the lens has a wide field of view, it will stretch out the foreground and make the most distant objects look minuscule. So, find things to populate the foreground and let them add something to the overall composition.

The smartphone camera has a little trick up its sleeve that will redeem it when it comes to shooting landscapes and wide scenes. Photographers comparing them with DSLRs will say that smartphone cameras can't perform well enough because they lack the ability to change the focal length of the lens and therefore alter the depth of field. However, a big DSLR lens is fairly large in comparison to its tiny sensor, whereas the tiny smartphone lens with its super-wide apertures of f/1.8 and f/2 has a much more favorable comparison in size between the lens and the sensor. This size ratio means that in certain circumstances, it actually performs like an f/18. So that's something to mention to all those naysayers out there!

ATTACHING LENSES TO YOUR DEVICE

A SIMPLE WAY TO DEAL WITH THE SHORTCOMINGS OF THE SMARTPHONE LENS IS TO BUY A LENS ATTACHMENT. I SEE A LOT OF RAINBOWS IN MY AREA, SO THE FIRST LENS I BOUGHT WAS AN ULTRA WIDE-ANGLE LENS SO THAT I COULD GET THE WHOLE ARC IN ONE IMAGE. FOR SHOOTING RAINBOWS ON MY iPHONE, I LIKE OLLOCLIP'S ACTIVE LENS COMBO, WHICH INCLUDES AN ULTRA WIDE-ANGLE AND TELEPHOTO LENS.

Look for lenses with the highest-quality glass possible. The best ones are made with ground glass and are at the pricier end of the scale. The price generally reflects the quality of the glass used. You should expect to pay a bit more for something that will give you great-quality results; as always in life, you get what you pay for.

It is fair to say that these lenses bring their own issues to surmount; for example, they can reduce the light-gathering potential of the fixed smartphone lens by one or two stops, potentially reducing image detail. The wide-angle lenses also struggle with distortion on the edges, and if you aren't holding your camera and lens straight on the vertical plane, you will see a curve appear in the horizon line in your images.

Here is some information about lenses if you do want to use them. You have three main choices for add-on lenses and four main types of lens attachments. I've also mentioned fish-eye lenses.

MACRO LENSES

These are the lenses that will get you up close and personal to your subject. You will be amazed at the detail you will capture in insects like beetles and butterflies if you can get close enough to them with your device. Some macro lenses come with a diffusion hood to help manage the light, but beware, they can make working with a live subject particularly tricky. (See pages 122–23 for more on Macro.)

FISH-EYE LENSES

A fish-eye lens is a specialized ultra-wide lens with a curved front portion that looks like a fish eye. It produces a circular image with an increasing amount of distortion from the center to the periphery. I haven't found a use for it in my style of work. The best application for a fish-eye lens, in my opinion, is to capture sports such as skateboarding and snowboarding, which often take place above a half-pipe. In these scenarios, the fish eye comes into its own, capturing the details of both the ramps and the action of the rider in the air.

EXPERT ADVICE

One final thing about lenses: I keep a lens cloth at hand—the kind you get when you buy a pair of sunglasses. I keep a lens cloth in my bag, my coat pocket, my car glovebox, and in my little camera accessories bag. And I use them often. Keep the fingerprints and smears off your lens—it needs to be clean to see properly!

WIDE-ANGLE LENSES

There are different focal lengths available under the banner of the wide angle. Wide angles can give you a greater area of detail in an image as the depth of field is potentially wider. However, there are some things to look out for, including lens distortion. It is most noticeable at the edges of the frame, where lines such as the horizon and building edges begin to look curved. You may also notice soft, out-of-focus areas creeping in at the edges. Try to avoid lenses that give a pronounced curve to the sides of images because it looks too much like a fish-eye lens and is distracting in almost every composition.

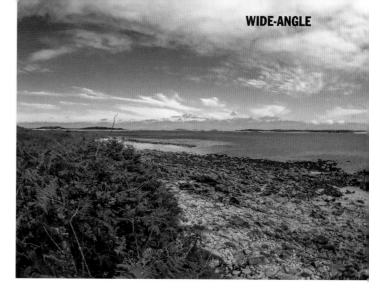

WIDE-ANGLE

TELEPHOTO LENSES

Telephoto lenses bring distant objects closer to you. They can also give you the opportunity to take a portrait with an intentionally blurred background, in a similar fashion to what you would expect with a DSLR camera and lens.

If you have one of these lenses, experiment with it to see how much it shortens the depth of field of your fixed smartphone lens. If you add a telephoto lens to your smartphone, consider increasing your ISO to compensate for hand-holding your device, because telephoto lenses will enhance the smallest movement and make it harder to shoot without blur. Speeding up your light-gathering abilities (see Shutter Speed on pages 32–33) will help compensate for this.

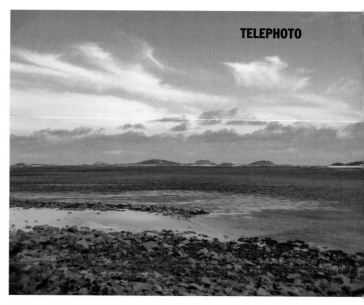

TELEPHOTO

STANDARD LENSES

Just for comparison purposes, here's a photograph shot with a standard lens from the same vantage point as the telephoto and wide-angle lens pictures.

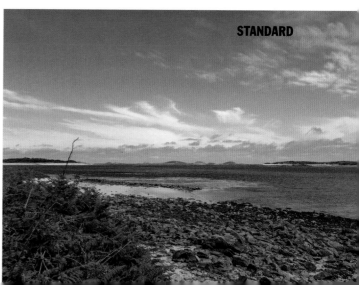

STANDARD

SUNRISE AND SUNSET

THE FIRST RAYS OF SUN PEEKING OVER THE HORIZON ARE A JOYFUL HERALD OF A NEW DAY. YOU WILL NEED TO BE UP WITH THE LARK TO GET SET UP IN TIME FOR THE SHOW TO BEGIN, SO BRING A FLASK OF SOMETHING WARMING AND MAKE AN OCCASION OF IT! I AM NOT A MORNING PERSON, SO I PREFER TO CATCH THE EVENING LIGHT SHOW. SUNSETS ARE CONSIDERED BY MANY TO BE A CLICHÉ, BUT WHO CARES WHAT OTHERS THINK— IF IT MAKES YOU FEEL GOOD, THEN TAKE THE PICTURE!

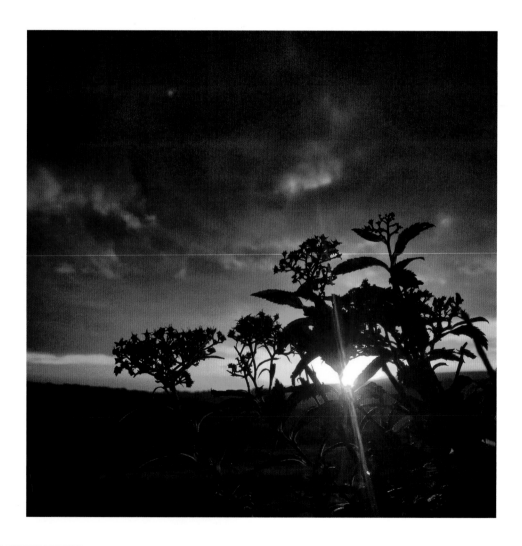

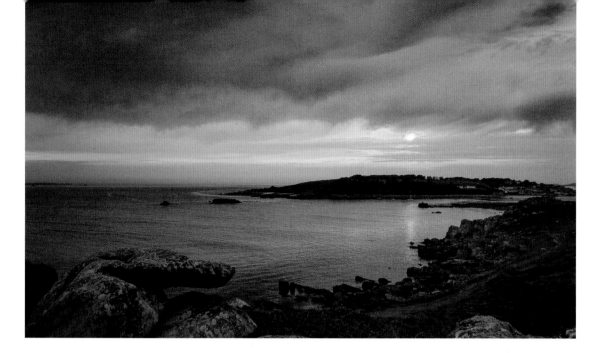

Use a tripod or fence post to rest your camera on for extra stability. And remember, even on the most overcast of days you may get lucky with a well-timed cloud break, so if the weather turns, don't pack up and leave until the show is over—clouds can really add drama.

Make sure the exposure is measured correctly to avoid blown-out skies, which lose detail and color intensity. See pages 29 and 31 for information on exposure compensation.

Sunrise scenes are often improved by the presence of swirling mist in valleys. Sunrises don't have to be all about warm orange colors either; there's a moody photo lurking in there on even the grayest

of days, which is lucky for me, given that I live in the UK, where gray clouds are part of daily life!

Try shooting some photos of the low sun with a strong silhouette in the foreground to give a different dynamic to some of your photos. Create the silhouette by simply exposing for the brightest part of the sky; this should throw your foreground detail into dark relief. If the silhouette is still not dark enough, use your exposure slider to bring the exposure down by another 1 or 2 stops (i.e. reduce the exposure so that the image is twice as dark or four times as dark). Android users can use the Pro Mode in the camera settings. To do this with an iPhone, you will need to use an app like ProCamera.

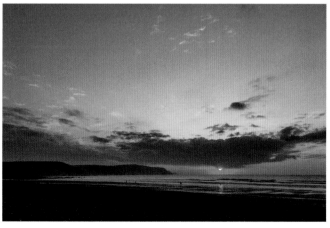

THE GLORIOUS GOLDEN HOUR

THE GOLDEN HOUR, MUCH BELOVED BY LANDSCAPE PHOTOGRAPHERS, OCCURS TWICE DAILY FOR A VERY SHORT TIME JUST AFTER THE SUN RISES AND AGAIN FOR A SHORT TIME BEFORE THE SUN SETS BELOW THE HORIZON. THE LONG, DEEP SHADOWS CAST BY THE LOW SUN AS IT BATHES THE LANDSCAPE IN ITS WARM GOLDEN GLOW MAKES FOR WONDERFUL PHOTOGRAPHS.

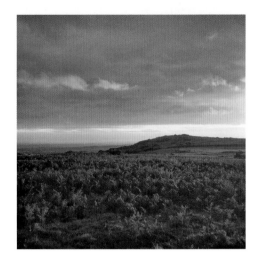

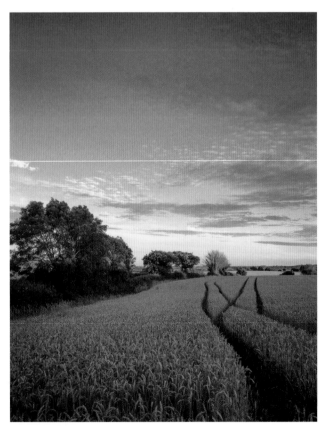

I find it easier to capture sunsets rather than sunrises, but that's just because I am not at my best first thing in the morning. But if you are an early riser, then the marvelous feel-good images to be taken at this time of day makes the effort to leave the house while it is still dark totally worth it. Whichever way you choose to do it, allow yourself enough time to get set up and ready well before the light show begins.

I love the way the golden light catches every blade of grass and dewdrop, and makes them glow, so look for places to capture this.

As the golden hour incorporates the sunrise and sunset, when the light intensifies further, try including some of the dramatic sunrise/sunset colors in your compositions. Consider shooting in portrait format rather than landscape format, so that you can make more of a feature of the drama in the skies.

If you can get to a pond or any body of water that catches the sun's rays, you'll be rewarded with the double bonus of a reflected sky in your landscape!

If you're really into making the most of the golden hour, plan your photo sessions in advance. You can nail the timings of the sun's movements across your location with apps like The Photographer's Ephemeris, which is available for iPhone and Android.

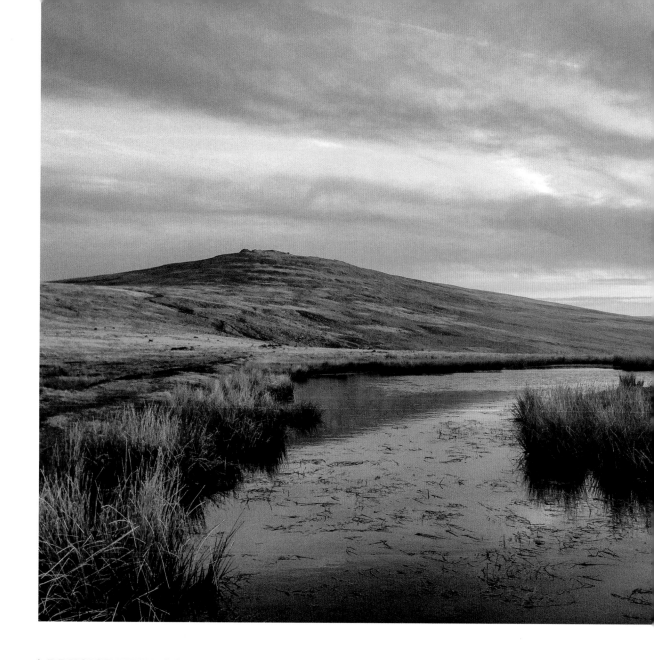

PRECISE TIMINGS

Technically speaking, in the morning the golden hour light phenomenon lasts from the moment of sunrise for about 25 minutes until the sun reaches a height of roughly 5° above the horizon.

In the evening the golden hour happens when the sun is roughly 5° above the horizon line. It will intensify for the next 25 minutes or so, until the sun slips away over the horizon line for another day.

THE MAGICAL BLUE HOUR

YOU MIGHT THINK THAT THE SETTING SUN HERALDS THE END OF THE DAY FOR PHOTOGRAPHING OUTSIDE, BUT TWILIGHT BRINGS ITS OWN MAGIC. SO BEFORE YOU PACK UP YOUR TRIPOD, LOOK AROUND YOU.

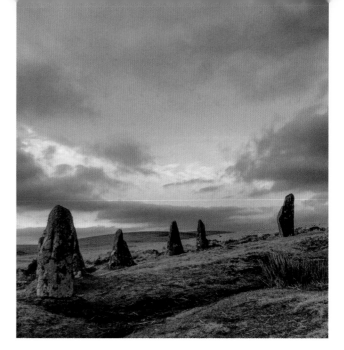

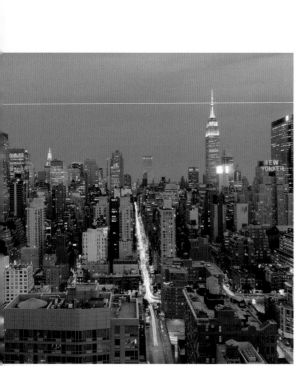

The golden glow of the sun has gone and the dying embers of the fiery sunset are fading fast from the sky, but the landscape is still lit by the shadowy light of the soft blues and violets we associate with twilight. This is a great time to see the moon appear in a light sky. Don't expect to see it looming large in your photos because this is not something achievable with a smartphone camera, but you will be able to capture it well enough.

This is the time and place for slowing down and putting some extra thought into your image-making. If you have a tripod with you, experiment with ISO and shutter speed combos. Think about your composition first so that you don't have to keep moving your tripod after you have set it up.

You will want to leave the shutter open for longer, particularly if you are in an urban environment where the combination of city lights coming on and car headlights will create amazing light trails. Try keeping your ISO at 400 and under to keep the noise down as much as possible, now dial your shutter speed up and down until you find the sweet spot where the tonal range is balanced from highlights to shadows.

If you have an Android, this can be done using the ISO and shutter speed sliders in Pro Mode in the camera settings.

iPhone users can open up apps like Slow Shutter Cam or NightCap Camera Pro to take this sort of photo. There is an added benefit here of harnessing the app's algorithms which do a fantastic job of managing the noise that is the scourge of smartphone photography in low light.

PRECISE TIMINGS

The blue hour light phenomenon begins in the morning when the sun's rays reach about 5° below the horizon line and will continue for about 25 minutes or so, until the sun peeps its head over the horizon line as sunrise itself occurs.

In the evening the blue hour starts when the sun slips away over the horizon for another day. It will intensify for about 20–30 minutes until the sun sinks to roughly 5° below the horizon and night time begins.

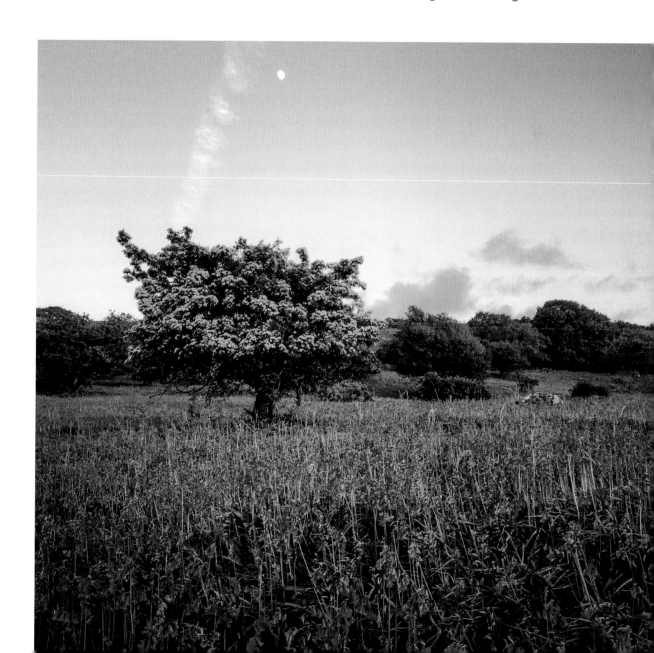

LOW-LIGHT AND NIGHT SHOOTING

I HAVE FOUND MYSELF ENJOYING A SUNSET CASTING ITS BEAUTIFUL LIGHT THROUGH A WOODLAND OR ITS EFFECT ON AN EVENING SEASCAPE BUT HAVE GOT HOME TO FIND THAT MOST OF THE PHOTOS I TOOK WERE TOO SOFT OR DOWNRIGHT BLURRY AND DARK TO USE. THE MORAL OF THE STORY? THIS TYPE OF SHOOTING REQUIRES A STEADIER HAND THAN MINE, PREFERABLY A TRIPOD, TO MINIMIZE THE BLUR.

Those with an iPhone will need to work with an app to over-ride the native camera and draw some more functionality out of it. Try an app like Slow Shutter Cam or NightCap Camera Pro to help your iPhone camera gather more light. Click on the gear wheel in Slow Shutter Cam to access the Capture Mode options, where you can select from motion blur, light trail, or low light. Then make a range of adjustments to fine-tune your image to perfection. My advice is to keep ISO at minimum and noise reduction at maximum.

It would be remiss of me not to mention the issues with noise even at low ISO values. Noise and low light go together, but you can avoid these as much as possible by keeping your ISO setting low. If you are shooting with an app like Slow Shutter Cam or NightCap Camera Pro, you will be amazed at how well they handle the low light levels and almost entirely eradicate noise issues.

If you shoot with an Android, you have everything you need already to make low-light photographs. Recently released Android handsets have a night shooting feature in their Pro Mode options. Just tap the moon and stars icon in the main Pro Mode screen to access it. See page 38 for more on Noise.

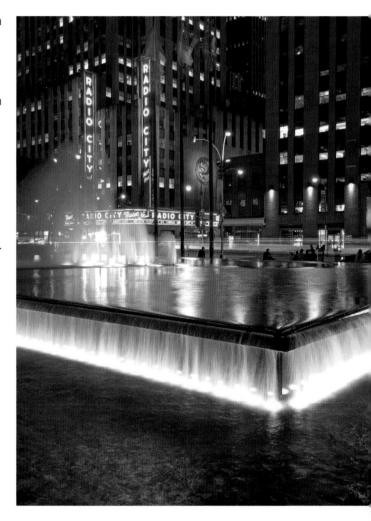

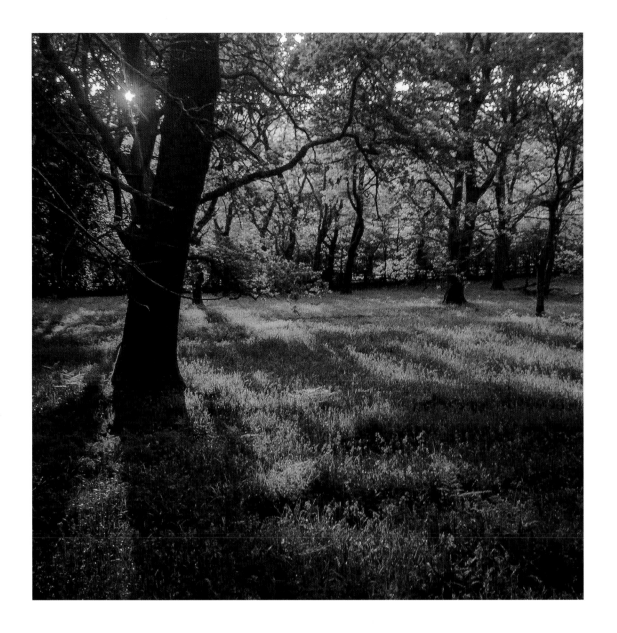

PATIENCE IS A VIRTUE

Patience is something every great photographer will have in spades. Learning to stay in the moment after you have taken that great shot, to be patient enough to keep looking for something more, will mean that you are in the right place and in the right frame of mind when an unexpected magic moment happens.

WHITE BALANCING

MOST PHONE CAMERAS ARE GREAT AT WHITE-BALANCING WITHOUT THE NEED FOR MANUALLY OVER-RIDING, BUT NOT ALWAYS, SO IT IS WORTH LEARNING HOW TO ADJUST THE COLOR TEMPERATURE IF NECESSARY TO IMPROVE WHAT YOU SHOOT.

When you take pictures indoors (with the lights on), they sometimes look a funny color and the white bits aren't very white. This is known in the trade as a color cast. The most common occurrence of a color cast is the one caused by household light bulbs, which give off a surprisingly yellow light. So how do you get around it? Well, turning the lights off won't work because it will be too dark! What you can do is use your camera to control this color cast by setting your own white balance. With this handy feature, you can point the camera at a white wall or a sheet of paper and take a reading to perfectly color-balance your pictures; it takes seconds to do and will make a huge difference. It is true that you can fix problems such as color casts using an app later, but it is far better to get it right in the camera to begin with and save yourself the time of fixing it later. All you need to do is open the white-balance function on your camera or app during editing (see The Editing Process and Snapseed on pages 130–31).

Go to Pro Mode on your Android.

You will either have a color temperature slider to experiment with or you may be offered the following settings:

▶ Sunlight/daylight

▶ Cloudy day

▶ Incandescent light

▶ Neon light

▶ Night time

▶ Flash

Select the option most appropriate to your lighting conditions or, if using the slider, just judge by eye which color best matches what you see at that moment.

Here's a rough guide to color temperature figures for the mathletes and number nerds among us...

KELVIN COLOR TEMPERATURE CHART

1,000–2,000K CANDLE LIGHT
2,000–3,000K INCANDESCENT LIGHT BULB
3,000–4,000K LOW SUN AT SUNRISE & SUNSET
4,000–5,000K FLUORESCENT LIGHT
4,000–5,500K MOONLIGHT
5,000–6,500K DAYLIGHT WITH CLEAR SKIES
6,500–8,000K OVERCAST SKY
9,000–10,000K HEAVILY OVERCAST SKY OR SHADE

CONCERT PHOTOS

A gig is a great place to practice your low-light photography. Here are some tips:

▶ Use Burst Mode (see page 34) to take multiple photos and choose the best one later.

▶ Get close to the stage if you want to capture facial expressions and detail.

▶ Turn your flash off. It is not worth bothering with because it just isn't powerful enough. Bear in mind that even for professional photographers there is a "first three songs, no flash" rule in the pit, so don't be tempted.

▶ Work with the stage lights to make the most of the colors and spotlighting. If you spend a few minutes watching their changing patterns, you will be rewarded with great shots.

▶ Stand still, hold your breath, and press your elbows into your sides to increase the steadiness of the camera while you take your shots.

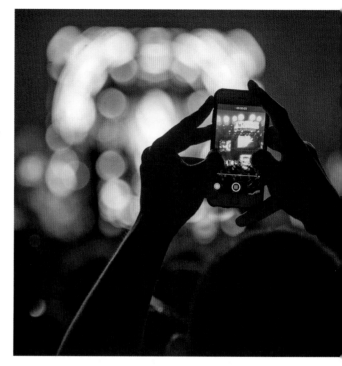

▶ Do not zoom in digitally!! Digital zoom sucks! (See Zooming In on page 17 for more on this). If you want to zoom in, add a telephoto lens attachment, but beware of increasing light loss issues when you do this.

▶ For better light gathering and noise control in these dark conditions, get the right settings for low light conditions. For an iPhone, try out a low-light app like Slow Shutter Cam or NightCap Camera Pro. On an Android, switch to Pro Mode, and use the custom Night Shooting feature.

CONTROLLING LIGHT WITH FLASH AND DIFFUSERS

MOST CAMERAS COME WITH A FLASH OF SOME DESCRIPTION. YOUR FLASH WILL ALLOW YOU TO TAKE PHOTOS IN ALL SORTS OF LIGHTING CONDITIONS, BUT WITH THIS FLEXIBILITY COMES A WHOLE HOST OF PROBLEMS YOU WILL NEED TO ADDRESS. THERE'S A RISK OF OVEREXPOSURE, AS WELL AS HARSH SHADOWS, HIGHLIGHTS, AND GLARING "HOT SPOTS" APPEARING IN YOUR PICTURES.

Techniques for overcoming these problems are simple enough though, so here are a few tips for fixing your flash problems.

You can soften your lighting dramatically by using a diffuser; it will eliminate the glare and hot spots you get with direct flash and will also reduce those hard shadows too. Diffusers come in collapsible, portable versions for filtering and diffusing direct light in your shots. A diffuser will reduce the shadows in your shots to nearly nothing. You can buy affordable ones with interchangeable sleeves to cover them in gold, silver, black, and white so that they double up as reflectors (see page 58 for more on reflectors). The diffuser sits between the light source and your smartphone, and it will diffuse that harsh burst of flash light, soften hard shadows, and give you more natural-looking photos. There are as many different types of diffuser as there are cameras, so you will need to find one that works with your flash. If you are on a tight budget, you can create your own for next to nothing. Over the years, I have seen people using a multitude of opaque household items to diffuse their flashes, from a piece of muslin (cheesecloth) to cigarette papers (see opposite). Just make sure that you only use white for your diffuser. If you use anything colored, it will cast colored light in your picture, and you probably don't want that unless you're feeling artsy.

FLASH

I AM NOT A BIG FAN OF FLASH PHOTOGRAPHY BECAUSE IT IS OFTEN QUITE HARSH AND UNFORGIVING, BUT IT IS WORTH KNOWING HOW TO USE FLASH IF THE NEED ARISES.

While it's true that the farther away the less harsh and fake the flash light will look, there will come a point where it has no effect on the image.

When you are working with portraits you may find that softening the effects of a direct flash is desirable. You can achieve this with a flash diffuser, which scatters the flash to reduce its harshness. Consider buying a selfie ring light flash attachment for your smartphone camera; they are inexpensive and are great for giving a diffused light for all sorts of photography scenarios beyond selfies—think food, flowers, still life, etc.

A super low-budget trick I have used with great success over the years is to carry a small pack of superfine cigarette rolling papers tucked away in my bag with my other photography accessories. You can wet the sticky edge and stick it to your camera so that it just covers the flash (make sure you're not obscuring your lens though). There you go, you have a highly effective and cheap, disposable diffuser!

See the Kit List on page 142 for more about diffusers.

USING A RING LIGHT

You can pick up a cheap and cheerful ring light flash attachment for your device. Ring flashes are also known as selfie lights and are basically large, hollow spheres that sit over the top of your phone. They work by distributing the light more evenly across the subject that you are photographing, which creates a subtle fill light. Ring flashes are loved by many a famous portrait photographer, and now you can mimic this on your smartphone. One of the many benefits of using a ring flash in a portrait photo is that it gives you a catch-light effect (a highlight reflected off the surface of the subject's eye) in the shape of a gentle curve that mirrors the curve of the eye itself. Get nice and close to see the effect of the light, but not too close, because it will make the catch-light very large and prominent, which may not be the effect you are looking for.

If it fits, try using a ring flash with a macro lens attachment for even light across the scene.

MODIFYING LIGHT WITH REFLECTORS

With all the new skills you have learned so far in this book, you should be using your smartphone camera more confidently. So now it's time to add some finesse to your photos. There are a few bits of inexpensive kit that can really make a difference to your photography, transforming good photos into great ones. Here are some simple techniques for working with diffusers and reflectors that will improve your lighting of subjects immediately.

A reflector is a photographic tool that is used to modify the light. It's a great way to increase the amount of light in your shots, and works by bouncing available light back into your photos, filling in the shadows with reflected light. If you place one opposite a window, it will bounce the light back into your scene. So placing your subject between the window and the reflector will help you eliminate harsh shadows and create more even light.

You don't need to buy a reflector—any large piece of white paper, card, or even a mirror will do the job right away. If you want to get creative, then paint a bit of board white, or roll out a sheet of aluminum foil to achieve the same effect without any expense. If you shoot a lot of portraits, products, or still-life photos, you might want to invest in a reflector with multiple options like white, black, gold, silver, etc. for different light modification effects. These portable and relatively inexpensive tools are usually collapsible, and believe me, it is often more challenging to fold them back into their bags than it is to use them to improve the light in your pictures!

You may find it hard to hold the reflector and shoot at the same time, so peg it to something if possible. Free yourself up further by using a tripod and a remote release gadget (see the Kit List on page 142) to trigger the camera shutter. Alternatively, unless you have a willing assistant to hold your reflector for you, make use of chairs, other furniture, or anything else solid and stable you can find to position the reflectors for your shot.

AMBIENT LIGHT

A smartphone camera works best in daylight. Natural sunlight, known as ambient or available light, is its forté.

Surveying a room at a squint will highlight the areas of light and shade to help you decide how to use light in the composition. Identify the brightest spot, usually by a window in daylight hours, and walk to it. Standing with your back to the window, notice where the light falls and pools, and how it illuminates the different objects in the room.

Using this method informs the decision about where to place the subject to ensure it gets the benefit of the room's ambient light.

HYPERLAPSE: THE THEATER OF LIGHT IN FULL EFFECT

If you aren't sure how much the light and landscape change even in the short space of 10 minutes, then go and find out!

If you are using an Android phone, you may have a hyperlapse feature in your camera settings. For iPhone and Android users without this feature, you can download the free hyperlapse app from Instagram and give it a go.

Pick a day with some clouds in the sky (you will struggle to see the effect on a cloudless day unless you record for hours!). Set up a tripod and point your camera at the landscape with the sun behind you or to the side, and start the hyperlapse recording. Let it run for 8–10 minutes if you can, which will produce a film long enough to see the effect of the light.

When you play it back (note that it works best with a playback speed of six or eight frames per second), the time lapse of the landscape should reveal how the sun and the clouds change the light on the landscape. You can also see the effects of wind and other weather on the landscape from a unique perspective. Be warned: hyperlapsing is highly addictive, but you can justify your new obsession because it is great training for tuning your eye to those changes in the light.

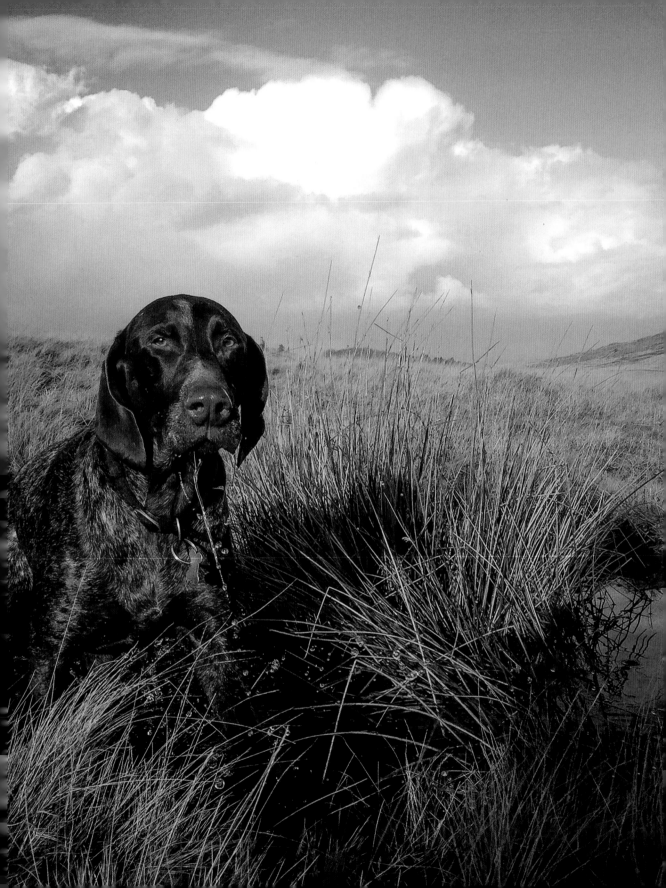

MAKING PICTURES

2

1

PLACES

THERE ARE PHOTO OPPORTUNITIES AROUND EVERY CORNER. HERE YOU WILL FIND EASY INSTRUCTIONS, PLUS PLENTY OF IDEAS AND INSPIRATION TO HELP YOU MAKE THE MOST OF ANY SCENE YOU WANT TO CAPTURE. BE IT URBAN OR COUNTRY, LAND OR SEA, THERE WILL BE SOMETHING HERE TO INSPIRE YOUR CREATIVITY.

CHAPTER 1 LESSON 1

CITIES AND URBAN LANDSCAPES

FORGET WORRYING ABOUT THE USUAL COMPOSITIONAL RULES WHEN IT COMES TO URBAN LANDSCAPES; THEY FEATURE A LOT OF INFORMATION WHICH IS ALL FIXED IN PLACE, SO APPROACH THIS COMPOSITION THINKING MORE IN TERMS OF BLOCKS, SHAPES, COLORS, LIGHT, AND SHADE.

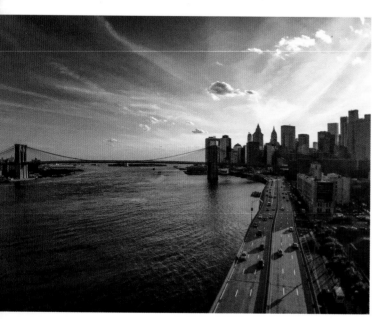
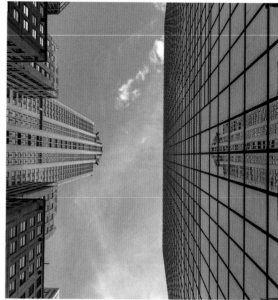

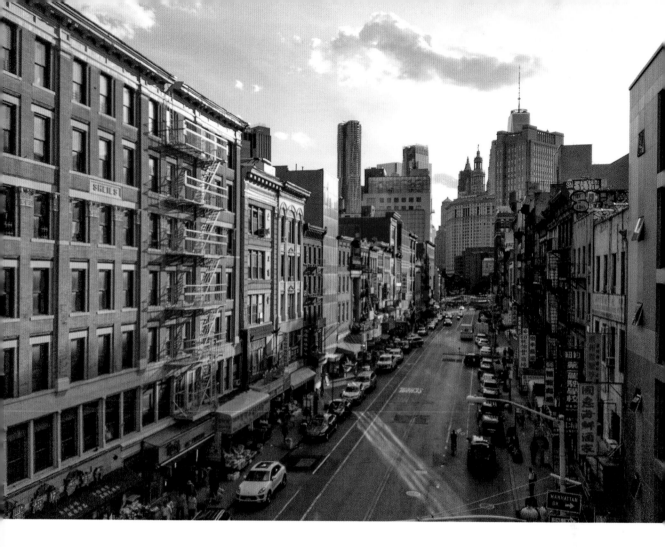

Try raising or lowering your angle of view for a shot that is a little more out of the ordinary, especially when photographing popular tourist haunts and famous landmarks.

A bird's-eye view gives a city a different perspective and creates a much more expansive scene. Find a bridge that you can cross or a high-rise building with a viewing deck to take some pictures this way.

Get down to floor level so that the road surface becomes part of the composition too. Bring a friend along to watch your back, and choose a quiet street and a quiet time of day to try out this technique.

Angle a street view so that it crosses the image diagonally, and look for opportunities for shooting buildings in the same way—you will get great leading lines and the whole composition will be more dynamic.

Give a wide angle or super wide-angle attachment a go, but be aware of the difficulties you'll experience in getting straight edges to your buildings—the exaggerated curve of the lens is not your friend when shooting buildings. But a few minutes spent in the SKRWT app (see Editing Case Study 2 on pages 134–35) will sort that out, so don't be put off.

Use your "tap screen to focus" skills to try focusing on different parts of the scene. Make some photos with the focus in the middle ground, and some where the focus is firmly in the background, thus making the entire range of the scene in focus.

You can see which focal point suits your shooting style and the subject later on when you are reviewing the whole set, so fire away now and give yourself plenty to choose from during the editing stage.

ARCHITECTURAL LINES

BUILDINGS ARE TRICKY THINGS TO PHOTOGRAPH. THEIR HEIGHT IN RELATION TO US TINY HUMANS MAKES IT AWKWARD TO GET THE COMPOSITION AND FRAMING RIGHT, BUT THAT'S NO REASON NOT TO TRY.

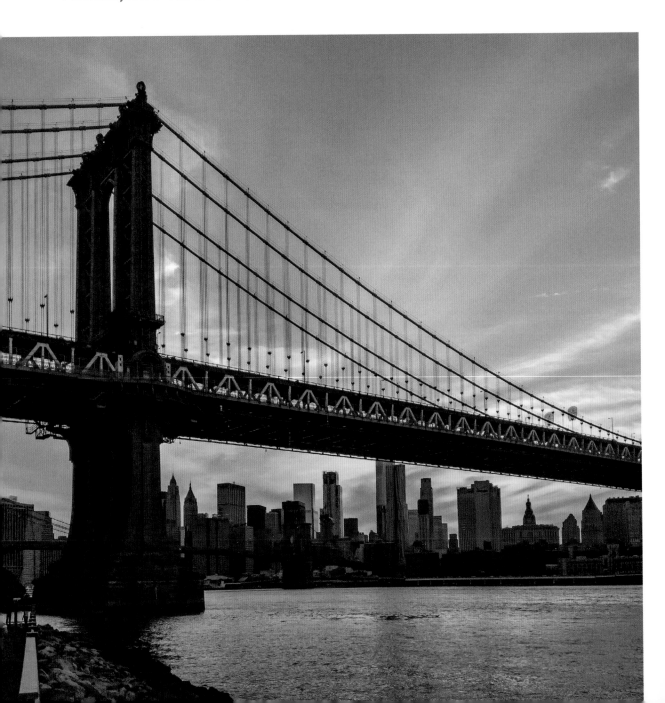

Use the screen's grid lines (see page 15) to help compose your scene. Pick a vertical line in your scene to be the focal point and line it up to the screen grid so it is straight; don't worry about the rest leaning, you can either live with it or try to fix that in the edit if necessary!

If you have a structure with lots of lines going in different directions, such as a bridge, make sure the bridge supports are straight along the vertical axis and form a neat 90° angle to the horizon line (which should be straight too). Follow this procedure and you will have done the best you can to manage a difficult composition.

Try stepping back a few paces to take in the whole of a building from a corner edge, so that you can see down two sides of the building at once. This instantly provides the composition with diagonal leading lines and a sense of enhanced perspective, giving a better impression of the building's true three-dimensional form. If those leading lines guide the eye to a point beyond the building where the landscape around the structure is visible, that's even better!

Look for opportunities to safely take photos of buildings from a bridge or anywhere that allows you to position yourself above ground level.

Buildings reflected in other buildings will lend symmetry to your pictures, so don't forget to look up and see if you can spot any!

If all else fails, look for some details to focus in on. Doors and windows close to eye-level are less likely to suffer from those pesky converging verticals (see right), and can give a good sense of the architecture of a building, so you could make a composition focused on those aspects.

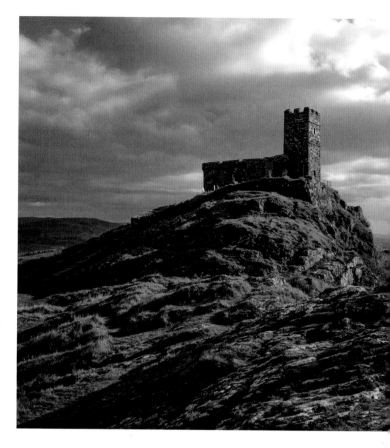

APP ADVICE

My favorite app to help sort out those wonky leaning buildings (known in the trade as converging verticals) is SKRWT. Along with its sibling app, 4 Points, it will fix any converging verticals, off-kilter horizons, and lens distortion issues you may encounter when taking pictures of architectural lines. Read more about Fixing Lines with SKRWT on pages 128–29.

LANDSCAPES

LANDSCAPE PHOTOGRAPHY IS ARGUABLY THE ARENA IN WHICH SMARTPHONES PERFORM BEST, OPERATING IN BRIGHT, AMBIENT-LIGHT SETTINGS. PHONE CAMERAS DO STRUGGLE WITH DYNAMIC RANGE (SEE PAGE 31), SO DON'T EXPECT TO SEE THE FINE DETAIL YOU GET WITH A DSLR CAMERA. HOWEVER, THE GOOD NEWS IS THAT THEY ARE GETTING BETTER WITH EVERY NEW RELEASE.

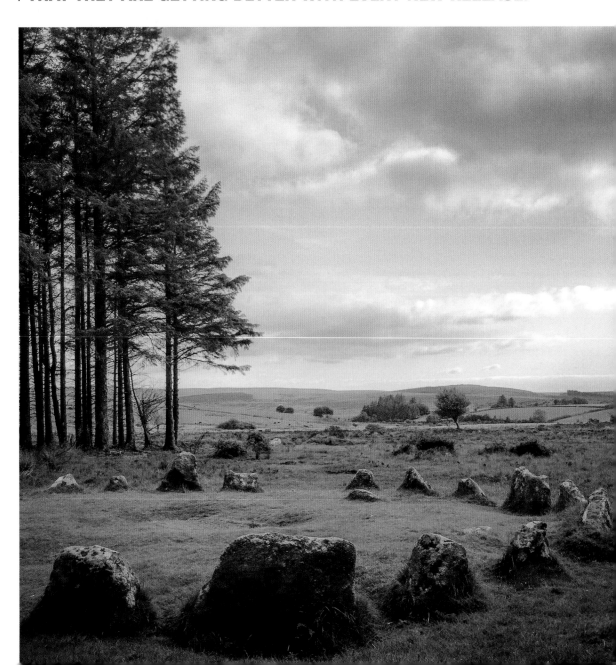

Put aside the desire to shoot distant landscapes and look for drama in your scenery—light and shade, stormy skies, sunbeams, rainbows—then capture that instead. Let the camera show the world you are seeing and feeling in that moment.

It's always worth checking the weather forecast before you step out the door, as I always say that there's no such thing as bad weather; there are just bad outfit choices. On the subject of planning ahead, you can check the sun's movements and timings across the landscape you are shooting by investing in one of those clever paid apps like The Photographer's Ephemeris or PhotoPills.

If you are concerned about detail, especially in distant subjects, try taking photos with interest in the foreground and/or the middle ground, as well as the background. Look for something to use as foreground interest that adds extra meaning to your photo rather than something completely random.

Choosing where to focus your image is also a key part of landscape photography—you want to avoid having the foreground or background out of focus. To focus correctly, identify the part of the composition that you need to focus on—it will be roughly a third of the distance to the horizon. The horizon line in your picture represents the upper edge of the area you should focus on (ignore the sky area, that doesn't count), so divide the space from the horizon down to the bottom edge of the frame into thirds, then focus on the spot that is one-third of the distance from the bottom of the frame to the horizon line in your image. Take a shot. Next, zoom into your photo to ensure it's sharp from the front to the back. If it's focused in the foreground, but the background isn't sharp, then you need to take another photo and move the focus slightly farther toward the background this time. Keep doing this as many times as it takes to get it right; it will be worth the perseverance.

It is a challenge to get a bright sky and shadowy foreground exposed correctly, but you will soon learn to manage your exposures. If you haven't read it yet, then now's the time to refer to the Exposure section on pages 28–41. The skills and techniques you need for shooting landscapes are the same regardless of the location or time of day, so once you have the knowledge dialed in, you can use it anywhere!

MANUAL CONTROL

If you want to use your native (built-in) camera rather than a pro app, just remember to focus on the desired area of your image and make an exposure adjustment before you begin snapping away. Taking control with an app and making manual adjustments will help you get a better picture—one that you have created with intention! It's easy to do, so set your ISO to 100 and leave it there, then adjust your shutter speed until you have the correct exposure for the scene.

See the Pro-level Skills section on page 29 for how to access your manual controls on iPhone and Android.

You can use your exposure compensation slider to tweak the exposure if you need to.

If your shutter speeds are slower than 1/60s, then you will need to put your device on a tripod or find some sort of support to avoid blurring.

FIGURES IN THE LANDSCAPE
MORE OFTEN THAN NOT, LANDSCAPES ARE ENHANCED BY THE ADDITION OF A HUMAN FIGURE PROVIDING A SENSE OF SCALE. FIGURES FUNCTION AS A GREAT COMPOSITIONAL DEVICE TO HANG THE REST OF THE PICTURE AROUND.

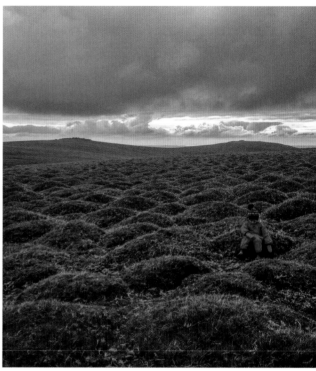

It is generally a good idea to stick with the Rule of Thirds (see page 14) as a guide, so try placing the figure on one of the lower intersecting points in the grid on your viewfinder (see page 15). But rules can be broken, as I have done in the above image.

Compose the figure so that you can see their line of sight across the landscape in the photo. Bear in mind that having a person look into the edge of the frame they are nearest to creates an awkward, closed-off composition.

Don't underestimate the power of a pop of brightly colored clothing against a muted landscape. If your figure is seated or standing still, you can get away with a slower shutter speed.

Who hasn't got fond childhood memories of puddle-jumping in rubber boots? Well, it makes a great scene if you're keen to capture a moving figure in a landscape. You will need a fast shutter speed (see pages 32–33), to freeze the action.

It matters to me to have balance between sky and the landscape in my photos. Perhaps it's because I live in a place with big, dramatic skies and stunning cloudscapes that I tend to be drawn to create images including these features.

I often choose to drop the horizon line to a low position in the image to give the sky the sense of enormity that it presents to me as I stand before it. Keeping the horizon line well below the center of the frame gives the sky more emphasis. This helps me achieve a dramatic photo that matches the feeling of being there in the moment, being reminded of how small I am in the grand scheme of things!

LIGHT ON THE LANDSCAPE

LIGHT IS THE KEY TO MAKING STRONG LANDSCAPE PHOTOS. PICK A SPOT TO SIT, WATCH THE LANDSCAPE FOR A FEW MINUTES, AND YOU WILL PROBABLY SEE THE LIGHT CHANGING RIGHT IN FRONT OF YOUR EYES.

The clouds overhead travel across the sky, leaving their trace below them as bursts of light and shade. The sun appears and disappears behind the clouds, casting occasional spotlights across the scene—an effect that I can't get enough of. Later in the day, as the sun drops in the sky, the lengthening shadows enhance the detail in the landscape even more.

You can kick back, relax, and watch nature's theater, and, as long as your camera is set up, it's no problem to fire off a few shots every time a fleeting moment of interest catches your attention. And believe me, they usually are fleeting, so don't get caught out: have your camera settings dialed in and ready to go.

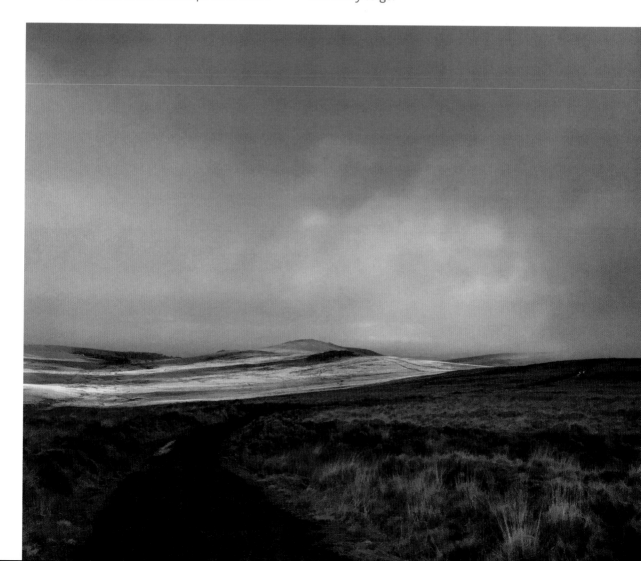

SEASCAPES

SEASCAPE PHOTOGRAPHY IS ALL ABOUT WEATHER, THE WAY IT COLORS THE OCEAN, THE MANNER IN WHICH IT REFLECTS THE SKY, AND THE MOOD IT CREATES.

Atmosphere in seascapes is created by the state of the sea, mist, sunsets, and cloudy skies. The time of day and the amount of natural light present when you shoot the ocean will influence a photograph, because the basic qualities of light—color, angle, and intensity—are brought into play on the reflective water surface. The best light for shooting seascapes is either early morning or from late afternoon to early evening when the sun is low in the sky, adding greater texture and detail to a photo. A strong, overhead, midday light will bounce off the water, often taking color and detail out of the water surface.

We have to work with what we have in a smartphone device, so the same advice that I have offered in earlier sections about using foreground interest to help balance the image is an important factor here. Break up the monotony of the continual tone and texture of the sea by including some rocks, beach, or people as foreground interest. Look out for opportunities to add in a seagull or sailing boat as the subject matter of the image and use the seascape as a backdrop.

Moments when the sun bursts through the clouds will create drama in your image, especially at sunrise or sunset. Hand-holding the camera for sunset photos across the sea is fine, but it may be preferable to get a tripod out or rest your device for extra stability.

Long exposures over the water are another great way to show the sea, with the movement of the waves smoothed over rocks or through a pier. See the section on Long Exposures of Water on pages 118–19 for more about this technique.

Your lens will get a greasy film of sea-spray on it when you are shooting seascapes, so wipe it with lens cleaning fluid and a clean lens cloth (you get them free every time you buy sunglasses, so repurpose one if you can). Just wiping your lens without fluid will smear the grease around and make it worse!

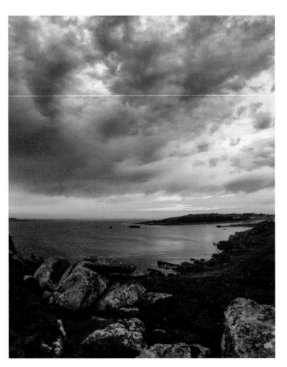

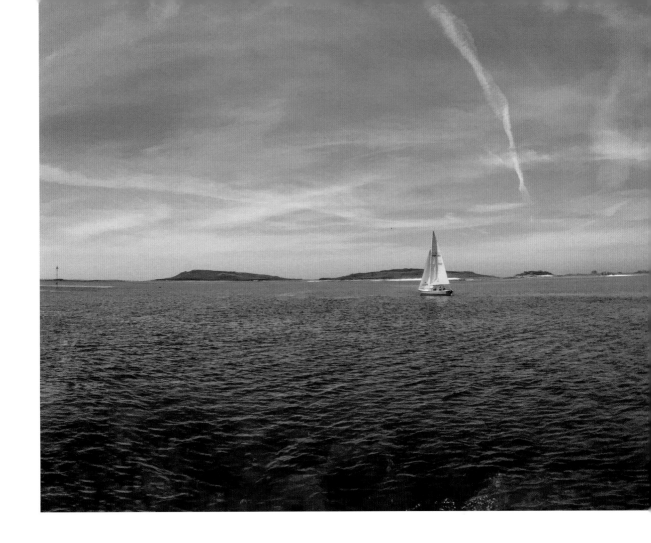

HARD LIGHT ON CLOUDLESS DAYS

Cloudless days present a hard light that can be challenging to photograph in. Hard-edged shadows and strong contrasts between light and shade will require a bit of extra thought during the composition stage. On the plus side, you will get lightning-fast shutter speeds. This is a good environment in which to explore your exposure compensation slider (see Shutter Speed Experiment on page 33). Bear in mind that the shadows will be strong and hard if you are reducing the exposure (i.e. reducing the amount of light let into the camera) to get the highlights under control. In this situation, it may be the most creative decision to consider the shadows as an integral part of the final picture and build them into the composition.

PEOPLE

WITH SIMPLE INSTRUCTIONS FOR TAKING GREAT PHOTOS OF THE PEOPLE IN YOUR LIFE, THE ADVICE IN THE FOLLOWING PAGES WILL MAKE YOUR PHOTOS SING. CHECK OUT ALL THE TIPS AND TRICKS FOR TAKING PORTRAITS THAT MAKE PEOPLE LOOK AMAZING AND GIVE YOU THE SKILLS OF A PRO.

CHAPTER 2 LESSON 1

PORTRAIT TIPS

HERE ARE A FEW TRICKS THAT ARE SIMPLE TO DEPLOY, WILL IMPROVE YOUR PORTRAIT PHOTOS, AND GIVE THE END RESULT A MORE NATURAL FEEL.

¾ VIEWS

Angling the subject to the camera, (sometimes called a ¾ view) can be more flattering than looking straight at them. Ask the subject to turn their feet, followed by their body, 45° to the camera, and request they turn just their head to look back at you.

When shooting a headshot at an angle, ensure that the subject's nose doesn't break the cheek line, as this will make it look longer. To minimize this effect, ensure that the tip of the nose is contained within the cheek area.

EYE CONTACT

When a subject looks straight at the camera, the unflinching gaze could be confrontational for the viewer. If they look away and out of the frame, it can make you wonder what they are thinking about and may add mystery to an image.

HALF- AND FULL-BODY PORTRAITS

For partial body portraits of just the upper body, line up the middle of your subject's chest with the horizontal center of the frame.

When you are shooting a full-body shot, it is best to have the subject's middle —their waist area—near the horizontal center of the frame.

Sometimes asking the subject to lean forward slightly at the waist will provide your shot with a more flattering line.

SAY CHEESE

Asking people to smile can create a false "camera smile" that often comes off feeling fake. If this happens, try having the subject looking straight at the camera with a neutral expression rather than smiling. Let the subject's face relax into one of repose, the way they would look if they were alone in a room and unconcerned about being seen. Waiting for this resting expression to happen may take time, but the reward will be an honest, more truthful facial expression.

However, sometimes a smile is exactly what the picture calls for. Discourage big grins, because it tends to make the face look strained. The eyes will also often squint and wrinkle, which isn't very flattering! For a hint of a smile, ask your subject to hum the letter E, because the mouth forms a similar expression as when saying "cheese," but it looks less self-conscious and more natural. It feels just silly enough for the smile to creep into their eyes as they do it, and you've got the shot!

LOW-KEY PORTRAITS

A LOW-KEY PHOTO IS A DARK IMAGE PUNCTUATED WITH HIGHLIGHTS, WHERE MORE THAN HALF OF THE SCENE IS DARKER THAN MIDDLE GRAY. MIDDLE GRAY IS EXACTLY HALFWAY BETWEEN 100% WHITE AND 100% BLACK.

This is a moody style of portraiture; the predominant darkness lends a dramatic and mysterious feel to an image. Using a single directional light source in a darkened room will do the job nicely. Use a dark background for this—either black or dark gray. At a push, shooting into a corner can help achieve this. Ask your subject to wear plain dark or black clothing because then it won't detract from the overall effect.

It is important to get the exposure on the face spot on. Try closing a set of dark or lined curtains and leave just a slit of light to illuminate your subject's face. Turn your subject's head to face the light and expose for the face. You may notice that the subject's hair blends and disappears into the background somewhat; this may be exactly the effect you want, but if you want to create some separation, add a fill light (an extra light that lightens an area of shadow) behind the subject. This can be easily done with a lamp or by using another window in the room. If you do have a second window, you can leave another slit of light to highlight the hair at the back, achieving a backlit layer to the low-key portrait.

If your subject is close to a wall, you may find that you can't entirely eliminate the wall from the picture. To fix this, move the subject away from the wall so that the light only falls on their face. The wall behind them will get darker as the distance increases.

SHOOTING INDOORS

Shooting indoors is all about window light. People often put the subject way too close to a window, and this can be a bit harsh and heavily contrasted. Instead, get them to move slowly back from the window and, as the light quality degrades, you will find that sweet spot of soft, clean light that flatters the skin.

If you have to work under just the room's tungsten or fluorescent lights, then double-check that your white balance is set accordingly. Tungsten lights in the room's lamps can create pretty lighting effects when combined with window lights, so give them a whirl if you get the chance. If you are stuck with just using fluorescent lights, opt to make black-and-white photos because this will disguise the horrible color cast from the fluorescents. Check out the info on White Balancing on page 54.

Whatever else you do, remember this one thing: you must capture the catch-lights (the bright spots of reflected light in your subject's eyes) to make it a successful photo. If you can't see them at first, keep moving your subject around until you see the light reflected in the top half of their eyes.

HIGH-KEY PORTRAITS

HIGH-KEY PHOTOS ARE THE BRIGHTEST OF IMAGES, AND ARE ALL ABOUT ELIMINATING SHADOWS. HIGH-KEY PHOTOS ARE LIGHTER THAN MIDDLE GRAY... MUCH, MUCH LIGHTER. UNLIKE THE DARK MOODINESS OF THE LOW-KEY PHOTO, HIGH-KEY PHOTOS GIVE OFF AN UPBEAT AND POSITIVE VIBE. THIS IS ANOTHER SCENE THAT WORKS BETTER IN A MINIMAL COLOR PALETTE LIKE BLACK AND WHITE.

The easiest place to shoot a high-key portrait with your smartphone is outside in bright sunlight with your subject standing in front of a white wall or some other light-colored backdrop.

The key tones in any photo are the mid-tones (mid-gray/neutral tones). So, with a high-key portrait, you are essentially pushing the mid-tones up to a higher level by brightening the overall image. This gives you the white high tones, forming the basis of the high-key effect.

Expose for the eyes by tapping on the subject's eyes in your screen and slide the exposure slider up slightly to brighten it; it is okay to overexpose by a maximum of +1 stop (see pages 28–41 for more on Exposure). Take a second shot where you expose for the eyes and leave it at that exposure; you will be able to push the exposure up in your editing apps afterward, so retaining some extra detail in the shooting phase will give you maximum latitude in the edit. Now you have two versions to work with later.

When you get to the editing stage, you can use Snapseed to push the highlights with tools like the Dodge and Burn brush and then get the effect you're after. For more about The Editing Process and Snapseed see pages 130–31.

BUILDING RAPPORT

Building rapport with your subject is a crucial skill for a portrait photographer. If you can relax your subject, it will pay dividends later.

It may help to engage in a shared activity that will take their minds off the photograph. You could ask them to play Simon Says for a few seconds, or to tap their nose, hold their breath, close their eyes, jump up and down, touch their toes, the list is endless. If you join in with them, it helps to foster a sense of union and camaraderie, and this will help create the trust you need between you to get that great portrait.

When communicating with your subject, try to be friendly and not too solemn or business-like. Keep your voice calm and soothing rather than shouting orders, and be sure not to criticize them. If they are not posing as you want them to, it is because you have failed to communicate what you want clearly, so take a breath and try again.

The advantage of spending time over your portrait photography is that it will give you the chance to calm down and get a feel for how it is going, to make changes calmly, and to find ways of making the experience fun for everyone.

OUTDOOR PORTRAITS IN AMBIENT LIGHT

HAZY DAYS ARE BRILLIANT FOR TAKING PORTRAIT PHOTOS BECAUSE THE SUNLIGHT IS DIFFUSED WITH ZERO HARSH SHADOWS, WHICH GIVES A SOFT FLATTERING LIGHT THAT IS GREAT FOR SKIN.

Sometimes the photo opportunity happens in full sunlight, though, but with some thought, you can still achieve a great portrait. Overhead sunlight as a primary light source can be a tough scenario for taking portraits. It is harsh and unforgiving, and causes large shadows under the eyes and nose.

Shade is the place to be if there is strong overhead sunlight. Search for a wall or tree that is casting shade and make use of that softer, dappled light. Look for interesting light patterns cast on the background to add interest to a scene. A bonus would be to find a white or pale wall that casts light back into the shade, acting like a giant reflector.

Once you have found the perfect spot for making the image, ask your subject to slowly do a full turn and look out for when their eyes feature that all-important catch-light. Ask them to move back and forth in the light—you will notice that there are points where the light is too strong and harsh, but as they gradually move away from the light, it will soften and you will find that sweet spot before they move too far away and the light quality begins to deteriorate and darken.

Focus on the eye as always in portraiture and work with your new-found rapport-building skills to pull off a perfect portrait.

FINDING YOUR PORTRAIT STYLE

Compare the images you take very quickly at the start of the session with those made after some time has passed. Do you like the ease of the early photos that are full of honesty and over with quickly? Perhaps you are drawn to the awkward self-conscious poses that appear after a while in front of the camera or even the bored and less self-aware images made at the very end of the shoot? Reflecting on these differences might provide a valuable insight into which type of portrait photography works best for you.

HEADSHOTS

HEADSHOTS ARE THE MOST INTIMATE OF PORTRAITS. THERE IS LITTLE ELSE TO PONDER IN THIS IMAGE: THE SUBJECT GETS YOUR FULL ATTENTION. PART OF THE REASON WHY THEY FEEL SO INTIMATE IS THAT THE FRAME IS CROPPED CLOSE TO THE SUBJECT.

A headshot is done face-on at a neutral framing angle, which means you should ideally frame it so that the end of the subject's nose falls roughly on the horizontal center of the frame. This neutrality is more than just a visual thing; by looking directly at their eye-line you are avoiding playing to inferred cultural notions attached to looking up at a person or looking down on someone, both of which are laden with societal undertones that may detract from the simple face-value interest of your portrait.

Once you have found a nice tight frame, have a look around the edges. If they have fly-away hair, try to let it exist within the frame and give it a small amount of space on either side. Try not to let any of their head, hair, or face touch the edges of the frame—this gives the image more space to breathe.

When shooting headshots, you can start with the standard lens on your smartphone camera. Avoid the temptation to zoom and just move yourself closer to the subject until they fill the frame. You may want to attach a lens for this type of portraiture. If so, go for a telephoto lens.

SEATED SUBJECTS

You will need to be precise with your focusing here, so make sure you tap to focus on the eye that is closest to the camera.

Experiment with different body lines and angles to see what works for you later in the edit.

Get up on a chair or low table to flatter the subject by looking slighty down on them; looking up at the camera will give them an instant facelift.

If the subject has lumpy shoulders in their clothes, use the TV news anchor's trick and get them to pull the back of their shirt down and tuck it under their bottom to smooth out the lines, or use a few pegs fastened at the back (out of sight) to pull the lumps and bumps out of their clothing.

This is perfectly suited to your wide aperture smartphone lens, which will create a soft effect and smooth out the imperfections slightly.

POSED PORTRAITS

When you pose someone for a portrait, you are offering a less truthful view of the person in the image. Your subject is now in collusion with you in the act of making the photograph, and this comes with its own considerations.

If you ask the subject to stand in a certain way, you risk losing the spontaneity of the moment and the resulting pose can be awkward to look at.

I always try to look down on the subject ever so slightly; as they look up at you they will stretch out those neck wrinkles and lose any hint of a double chin! Beware of having the subject's head tilted too far back, though, because it will elongate their nostrils. Find the sweet spot in between.

Take a good, hard look at what they are doing with their hands, because these can be very distracting and easily make an otherwise great portrait look awkward.

Try using a telephoto attachment to focus on the person in your picture; it will allow the subject to stand out nicely from a blurred background— portrait gold!

BLACK-AND-WHITE PORTRAITS

SHOOTING PORTRAITS IN BLACK AND WHITE IS OFTEN MORE EFFECTIVE FOR EXPRESSING THE CHARACTER AND MOOD OF A SUBJECT.

Compositions that are based on areas of light and shade will benefit from a black and white color palette, as this will reduce the image to just those stark tonal contrasts. Once the distracting color elements of the image have been removed, the picture is free to express more about its lines, shapes, and tones.

LEAD ROOM

Have subjects looking into the image rather than looking at the edge nearest to them. Frame them so that their line of sight is across the image frame and not butting straight up against the edge. Invite the viewer into your picture by offering them a sense of what the subject is looking at: let them be part of it.

STREET PHOTOGRAPHY

THERE ARE SPLIT-SECOND STORIES AND FLEETING MOMENTS PLAYING OUT AROUND US CONSTANTLY. STREET PHOTOGRAPHY IS MOST OFTEN CARRIED OUT ON BUSY CITY STREETS, BUT ALL PUBLIC SPACES ARE POTENTIAL GOLDMINES FOR FINDING GREAT "STREET" PHOTOS.

While it may seem like an easy thing to do, street photography is probably one of the most challenging types of photo-making out there; it requires patience, guile, and a bucket load of serendipity.

The ability to blend in is key to achieving candid, honest images. This is where you are at a great advantage with a smartphone, because people aren't that concerned with what someone waving a smartphone around is doing; they're usually too engrossed in their own screens to give it a second thought!

Identify the spots that people might hang around without drawing attention; a bus stop is a great example of this. To make you even more invisible, wear headphones and pretend to make a video call while waiting with a raised phone for someone to wander into view and complete your shot. Sit down with your phone resting in your lap to shoot from below eye-level without attracting the slightest bit of attention.

Color can become a valuable subject to you. Look for scenes where areas of color communicate with each other. A color in a billboard might complement the color of a coat or dress, for example. It can help to squint your eyes until they are almost closed and try to see the scene as a palette of colors.

For more street photography tips, see the section on Street Photography in Black and White on pages 86–87.

EXPERT ADVICE

Consider setting your ISO at around 400 to give you the freedom to flit in and out of the shadows without having to fiddle with dials to change settings as you shoot, because this may get in the way of you capturing that "decisive moment." Shutter speeds below 1/60s are likely to pick up the shaking and blur associated with hand-holding, so, if necessary, push your ISO a bit higher to keep your shutter speed well over 1/60s.

STREET PHOTOGRAPHY IN BLACK AND WHITE

MANY STREET PHOTOGRAPHY IMAGES WORK MUCH BETTER IN BLACK AND WHITE. IT'S A GAME OF TONES, SO LOOK OUT FOR AREAS WHERE LIGHT AND SHADE PLAY A SIGNIFICANT ROLE IN THE COMPOSITION. SHOOTING EARLY OR LATE IN THE DAY WILL GIVE YOU THE MOST DESIRABLE SIDE EFFECT OF THE SUN'S LOW POSITION: LONG SHADOWS.

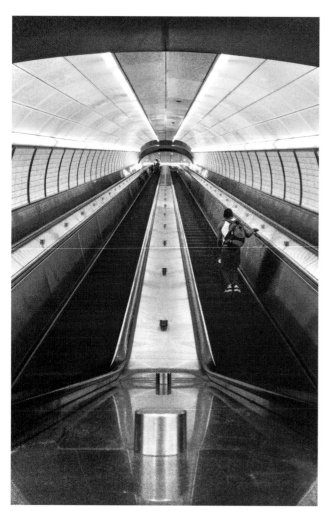

The usual fundamental rules of photography apply here: go for a strong composition and bear in mind that the rule of thirds, lines and diagonals, symmetry, and reflections are all potentially key aspects of your photo.

Hone your photographic eye to find places that could be the setting for an extraordinary moment to occur. Look out for shafts of light, puddles, stairways, contrasty areas between strong light and deep shadows, pedestrian crossings, reflective windows, and pools of light outside shops and bars as potential starting points. Be prepared to wait hours or even days to witness that fleeting moment play out. It is imperative that the camera is set up and ready to capture the moment when it finally presents itself; there may be just a split second when all the elements come into alignment, and in that moment, you need to be firing the shutter in Burst Mode (see page 34 for more about burst-mode shooting). Hopefully the perfect frame will be among the many frames you take, a fitting reward for your preparedness and patience.

I prefer to shoot street photography in color and then work with the VSCO app's black and white filters later to change my image from color to monochrome. For more about editing in VSCO, see page 129.

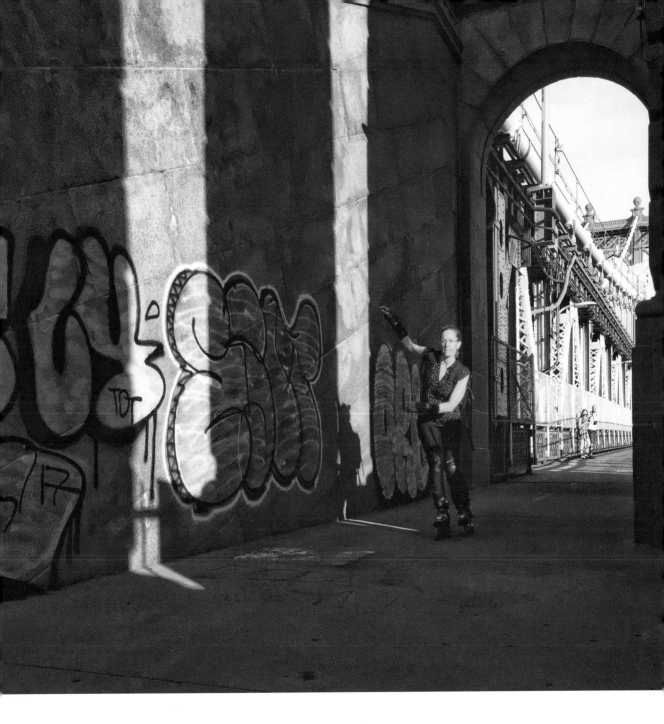

PRIVACY CONSIDERATIONS

In most areas of photography, there are laws in place to protect people's rights, but street photography still carries with it a lot of freedoms, given that anyone in a public space can have less of an expectation of privacy.

FREEZING FAST-MOVING ACTION

WHEN PHOTOGRAPHING CHILDREN PLAYING OR ANY FAST-MOVING SPORTING ACTIVITY, USE FAST SHUTTER SPEEDS OF 1/1000TH OF A SECOND AND OVER TO FREEZE THE ACTION.

Press and hold the shutter button down to use burst mode and take multiple frames per second (fps) so that in the editing stage, you have every chance of combining the frozen action with an interesting and balanced alignment of the picture elements.

BREAK THE RULES

Look for ways to convey the speed, motion, and hyperactivity of your action shot. Let some parts of the subject be outside the frame, and allow a certain amount of blurring to occur, or shoot from a very low angle to enhance the statuesque physique of the subjects. Try to channel energy into your pictures!

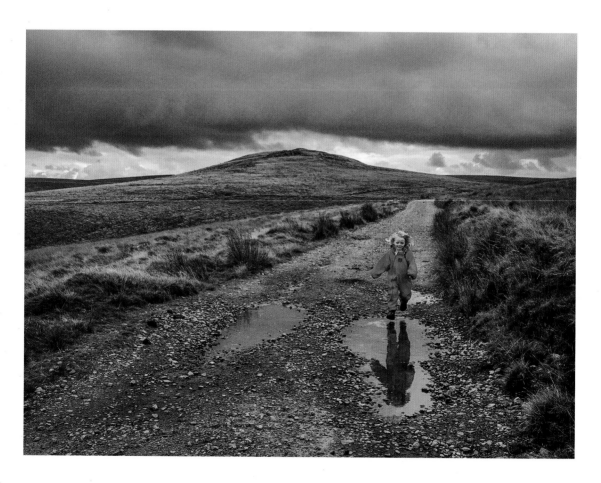

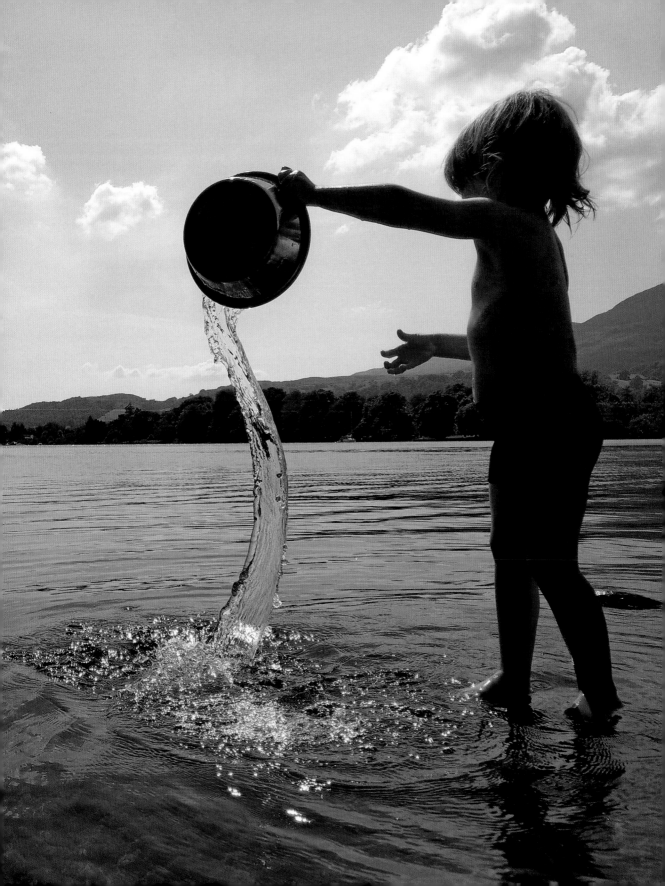

3 NATURAL WORLD

NATURE IS PACKED WITH INSPIRATION FOR PHOTOGRAPHERS, SO IF YOU WANT TO USE YOUR SMARTPHONE TO MAKE BEAUTIFUL PHOTOS OF ALL THE WONDER AROUND YOU, THIS IS THE CHAPTER TO READ. PACKED WITH SIMPLE IDEAS AND MY TRIED-AND-TESTED TIPS AND TRICKS FOR ACHIEVING PERFECTION, YOU WILL BE AMAZED AT WHAT YOU CAN ACHIEVE.

WEATHER: MIST

MIST IS ONE OF THOSE GREAT OCCASIONS WHERE THE WEATHER IS GIVING YOU A NATURAL DIFFUSER TO WORK WITH. THERE IS SO MUCH YOU CAN DO WITH MIST; EVEN A THICK FOG CAN PROVIDE INTERESTING MOMENTS FOR THOSE PHOTOGRAPHERS BRAVE ENOUGH TO VENTURE OUT ON A MAGICAL MYSTERY TOUR AROUND A SUDDENLY UNFAMILIAR LANDSCAPE. I AM ALSO SOMETHING OF A TREE-IN-THE-MIST ADDICT— IT'S MY GO-TO OPTION IN THESE WEATHER CONDITIONS.

Mist imparts such atmospheric moodiness that it is definitely worth getting out amongst it. Look for urban lights in cities or majestic trees in the countryside that pierce through the misty gloom.

This is a rare occasion when putting the sun in front of you as you take a photograph may yield some interesting results, so give it a go.

Hang around long enough to watch the mist dissipate as the day heats up. Often, the most dramatic scenes happen as a sunbeam pierces though the clearing mist and casts a glow across a partially shrouded landscape.

A misty sunrise is ethereal and otherworldly. At certain times of the year you will be able to photograph valley mist at dawn too. So go up to a local high point and see if the sky clears. When the mist sits below you and the sun is above it, you get the effect of a white ocean, often affording you tantalizing glimpses of hills, trees, or buildings poking through. As the sun burns off the mist, you will get some atmospheric and memorable photos.

Experiment with your exposure compensation slider (see pages 29 and 33) to get some slightly under- and over-exposed versions, so that you will have more to work with when you edit later. Use your exposure slider to alter the exposure marginally either way. To do this with an iPhone, use an app like ProCamera. Android users can use the Pro Mode in the camera settings.

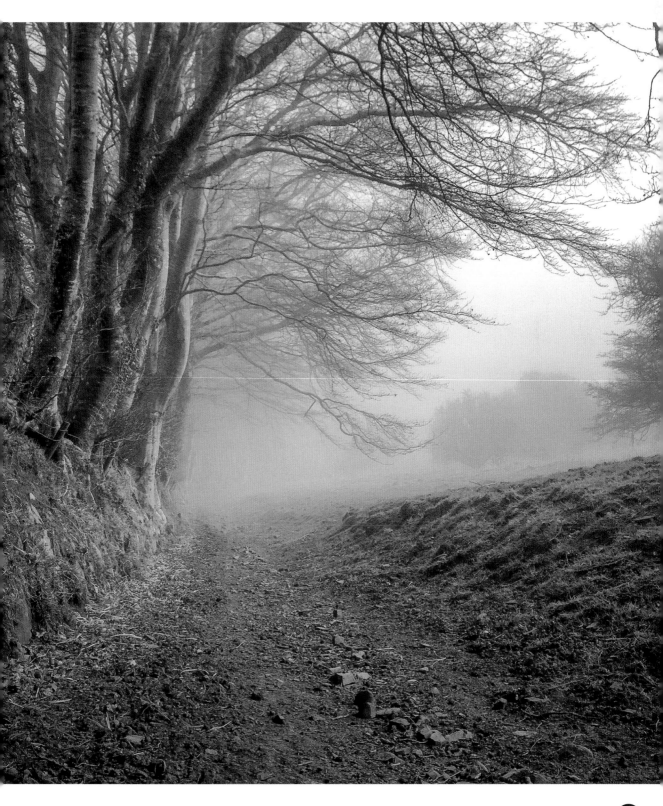

WEATHER: OVERCAST DAYS

DON'T THINK THAT YOU CAN ONLY PHOTOGRAPH THE LANDSCAPE ON CLEAR, SUNNY DAYS; YOU WILL FIND THERE IS PLENTY TO RECOMMEND BEING OUT UNDER CLOUD COVER AS WELL. BLANKET CLOUD CAN ACTUALLY MAKE FOR INTERESTING PHOTOGRAPHS BECAUSE IT BASICALLY ACTS LIKE A FULLY IMMERSIVE DIFFUSER.

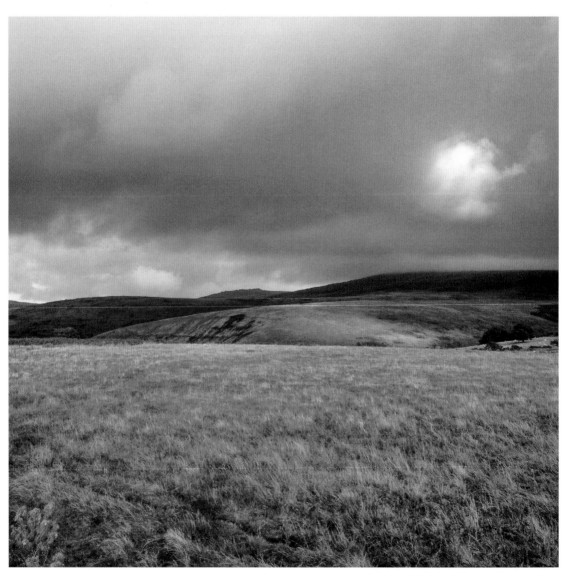

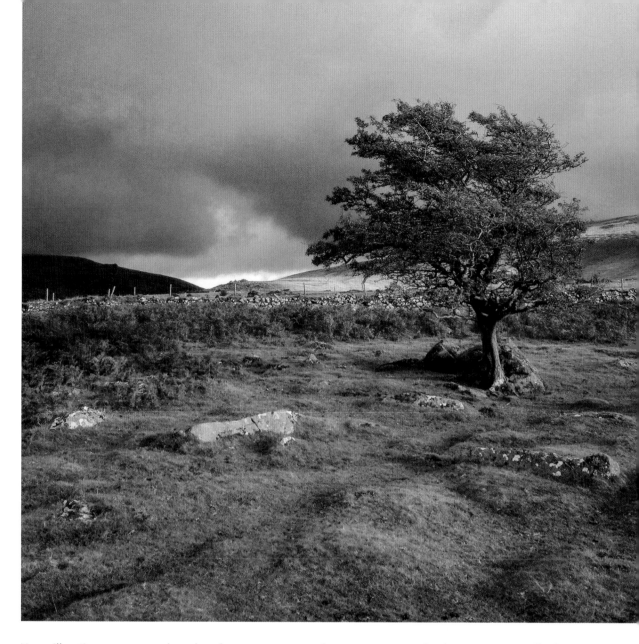

You will notice on overcast days that there are no strong contrasts of light and shade to deal with, producing tonally smooth images that feel soothing and calm. Go with this, exploit the conditions, and capture images like waterfalls with long exposures in the reduced light. For more on Long Exposures of Water, see pages 118–19.

From time to time, a shaft of light may break through the cloud cover. Its effect on the landscape will make for a fantastic photo opportunity so look out for those moments. You will probably be able to make some great moody photos too, especially if you can find some detail in the clouds to expose for.

Bear in mind that overcast skies are still fairly bright, so this is a good time to experiment with sliding your exposure scale up or down by a half or full stop at least. You can fine-tune the exposure later on with your editing apps, so for now just collect some images at these various settings; it's all grist for the mill, as they say.

For more about stopping down your exposures, see page 36; for more about editing apps, see page 130.

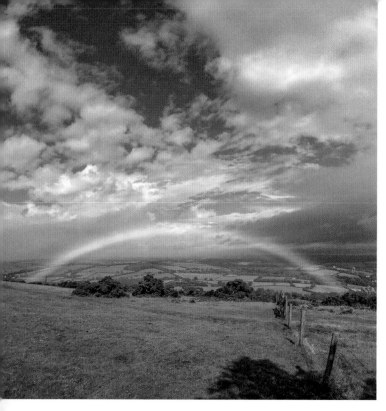

WEATHER: RAINBOWS AND STORMS

WILD WEATHER IS THE NORM WHERE I LIVE, SO I HAVE GROWN ACCUSTOMED TO SHOOTING IN IT. GENERALLY, THE ISSUE ISN'T BAD WEATHER, IT'S BAD OUTFIT CHOICES, SO IF YOU'RE KITTED OUT APPROPRIATELY, THERE IS NO REASON WHY YOU SHOULDN'T BRAVE THE ELEMENTS TO MAKE PHOTOS THAT SING WITH ENERGY AND LIFE.

Over the course of my life as a photographer, I've come to learn that inclement days are when the light is at its best, giving plenty of photo opportunities of dramatic clouds, shafts of light, colorful rainbows, and storm fronts passing across the landscape.

Low-key landscapes, where most of the tones in the picture are at the darker end of the scale, are in abundance in bad weather, so look out for the drama of dark and brooding cloudscapes.

Expose for the brightest patch of sunlit or cloudy sky. This will mean that some of the darker areas of the landscape look underexposed, but don't worry about that now—you can fix this issue later during the edit stage (see the section on The Editing Process and Snapseed on pages 130–31).

Rainbows occur as the sun peaks out when it's raining, so that's as good a reason as any to be out in the rain or drizzle with your camera at the ready. Focus on the rainbow and expose for the brightest area of sky. Shoot some panoramas of rainbows to fit the whole arc in the shot and, if you have one, make some photos using a wide-angle lens attachment too.

Take a lens cloth to keep your lens dust- and rain-free. I keep mine inside a sealed plastic bag that is large enough to stash my phone in, should I need to.

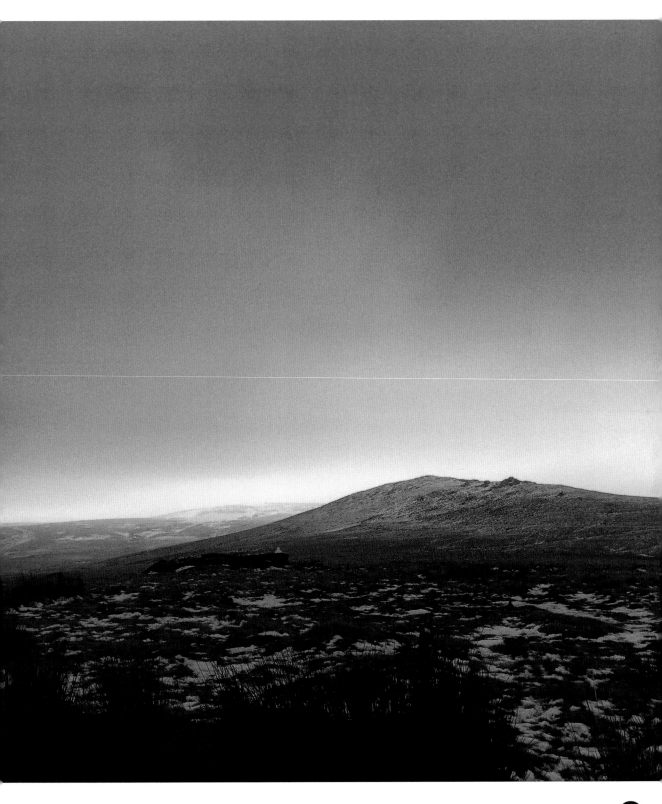

WEATHER: SNOW

AN ALMOST MONOTONE EXPANSE OF LANDSCAPE IS A WONDER TO BEHOLD, BUT SNOW PHOTOGRAPHY COMES WITH CHALLENGES, ALL OF WHICH ARE EASY TO OVERCOME WITH THE FOLLOWING THOUGHTS FIRMLY WEDGED IN YOUR MIND.

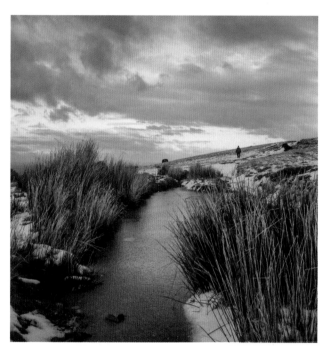

Shooting in the snow is tricky when the sun is out because it will be hard to avoid overexposing with so much white and brightness in the scene. Wait for the sun to be diffused by cloud, or move so that it is partially or fully blocked by buildings or trees.

Look for leading lines and pops of color to add contrast and break up the monotony of a snow-covered landscape.

The snow may be largely white, so make the most of the color and light in the sky, especially during the golden and blue hours. (See The Glorious Golden Hour on pages 48–49, and The Magical Blue Hour, on pages 50–51, to learn more about photographing in these two light conditions.)

You could also try using a macro lens to see if you can capture individual snowflakes and close-ups of icicles.

Blue color casts (a kind of blue filter effect caused by your camera underexposing and seeing the snow as a mid-tone) are a common problem in snow photos, but they are easily fixed! To help you in the edit, take photos where you have exposed for different parts of the scene so that you have the best chance of having the perfect shot in the bag. Use your editing skills later to reduce any blueness (and even experiment with adding a tiny bit of warmth). See pages 130–31 for advice on editing in Snapseed.

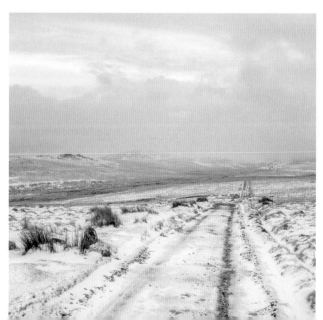

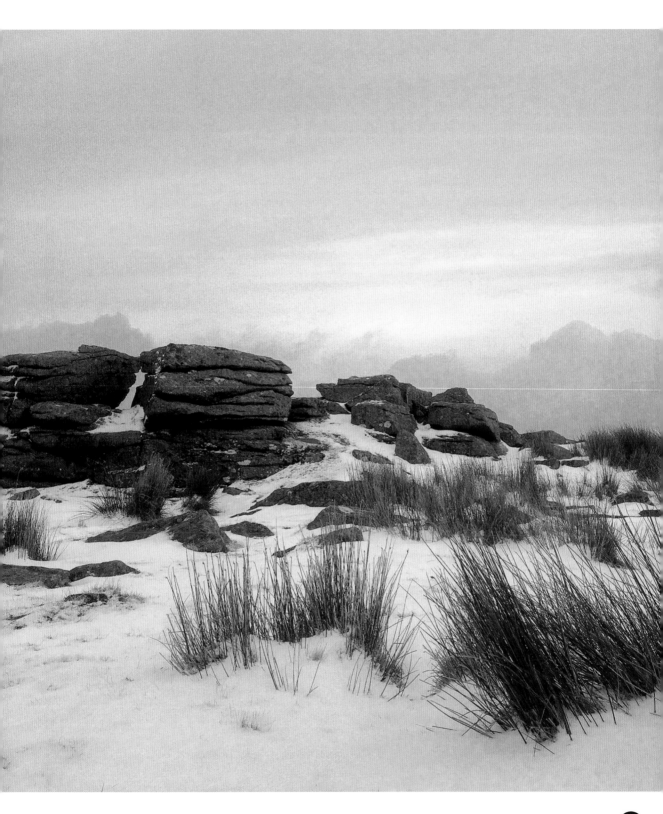

ANIMALS IN LANDSCAPES

COMING ACROSS AN ANIMAL IN A LANDSCAPE IS A BONUS FOR ENHANCING YOUR COMPOSITION. IT WILL GENERALLY HELP GIVE A SENSE OF SCALE AND ADD AN EXTRA LAYER OF INTEREST TO THE IMAGE.

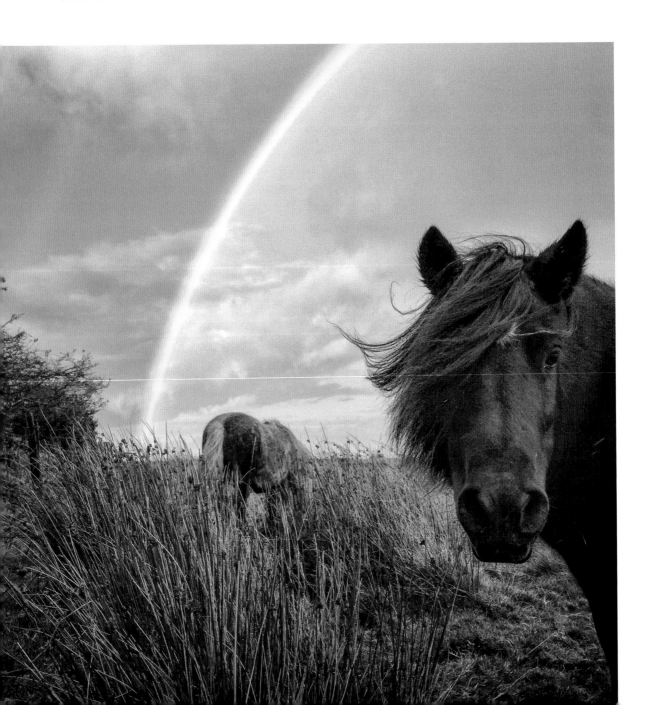

For herds of animals, look out for moments when they naturally form a line or triangle formation. For single creatures, think about composing with the animal's back end near the edge of the frame so that it is looking into the picture with its line of sight across the landscape. Avoid photos of animals looking at the nearest edge of the frame with a big gap behind them; it feels uncomfortable and denies the viewer the opportunity to share the view with them. Adhering to the rule of thirds as a compositional guide and placing the creature off-center on one of the intersecting lines in the grid on your screen will help you achieve this.

For more about composing with the Rule of Thirds, see pages 14–15.

For more about adding a grid to your screen, see page 15.

Consider getting down lower than the creature(s) by kneeling or crouching so that you can look up at the sky behind them as well. I like to look for angles that will enhance the sight of the wind fluttering their manes or emphasize the length of their eyelashes.

Tap on the creature's eye area to focus. Underexpose by at least one-third of a stop (one notch toward the "-" symbol on your exposure slider). This will get highlights such as the clouds exposed properly; don't worry if the animal is dark and is hard to see in the exposure—you can easily fix this in the editing stage!

For more about dealing with dark areas when editing, see Sky and Landscape Exposure Balancing on page 131.

Use the standard lens and make the most of its wide-angle possibilities.

Using a telephoto lens attachment will help you get a stronger composition if the animal is too far away and may help you feel more confident about photographing it.

To learn more about Lenses, see pages 44–45.

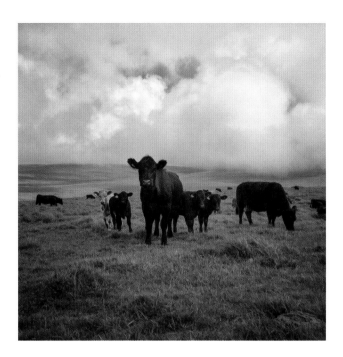

SAFETY

Photographing animals in their natural environment requires a few sensible precautions. Keep a safe distance and always stay well clear of hooves and horns. Try to avoid alarming them in any way. Move slowly and softly, and do not speak loudly or shout at them. I tend to click my tongue soothingly to get them to look my way; I find that it usually produces a curious glance in my direction, and I get a great shot as they prick up their ears and make eye contact. Give animals with young extra respect because they are more likely to feel threatened by you and act accordingly. Know your safe exit route at all times and never ever get in a field with a bull—that's just foolhardy.

PETS

I ADORE MY TWO GERMAN POINTERS AND PERHAPS I AM BIASED, BUT I MUST SAY, THOSE BOYS ARE SO PHOTOGENIC! THEY AREN'T ALWAYS THAT GREAT AT POSING FOR MY PHOTOS, THOUGH; LIKE ALL ANIMALS THEY HAVE THEIR OWN AGENDA.

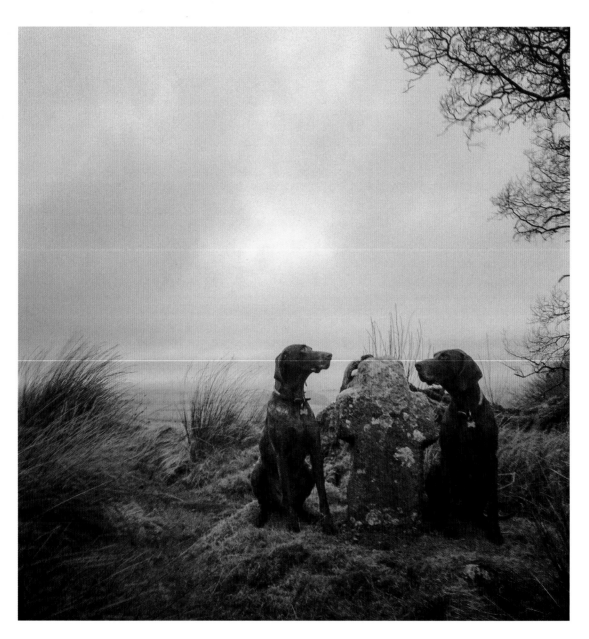

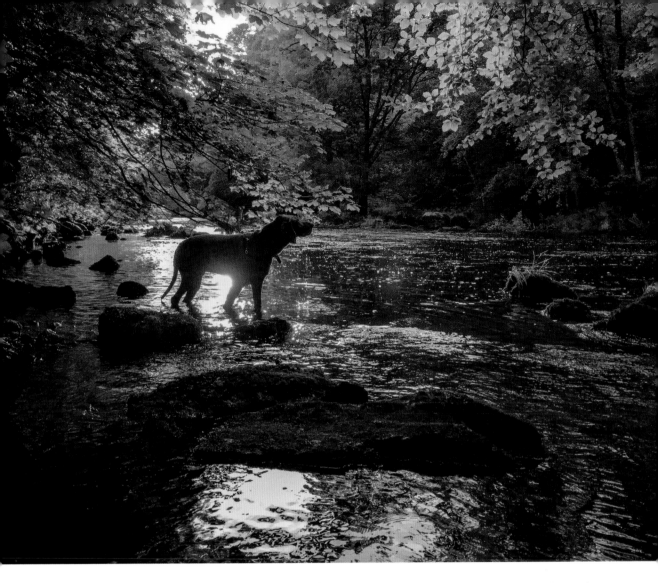

Try to shoot pets doing something they enjoy, perhaps running around after a stick or lazing on the windowsill. This way, you will get a more honest photo of the true character of your pet. Take your photos outside for the best ambient lighting. If you can't manage that, then work near a window in natural light instead. Sticking with natural lighting helps to prevent red-eye. Avoid using a flash as this might upset your pet.

Don't tie the animal up or try to force it to sit still or pose, because this rarely looks comfortable. Let them relax around you, be patient, and you will get a better shot. Once your pet is relaxed, if you click your tongue, call quietly, or whistle softly, they will probably look in your direction with an alert and interested expression for a few seconds, so be ready for this moment!

Get down to their eye-level and sit or lie on the floor with the light behind you, so that when the animal looks at you, you can see the catch-light (the little spark of light that is reflected in their eyes). Always tap to focus on the eye area; if the eye is out of focus, the portrait just doesn't work.

If you have a animal with dark coloring, you'll find these tend to be a bit more difficult to photograph. Check out the section on selective adjustments in Snapseed on page 131 for tips to fix this.

And finally, I have been known to produce a treat and resort to bribery to get the shot. I will leave that one with you to consider!

URBAN PETS

OF COURSE, NOT EVERY PET LIVES IN THE COUNTRYSIDE. URBAN POOCHES LIKE THESE DOGS IN MANHATTAN RULE THEIR NEIGHBORHOODS!

Taking pet portraits on the city streets requires a slightly different approach; letting an animal off a leash can potentially create havoc in the road, so think about including the leash and the owner's feet in the photo for a real sense of who these pets are and who they belong to. Other than that, follow the instructions on page 101.

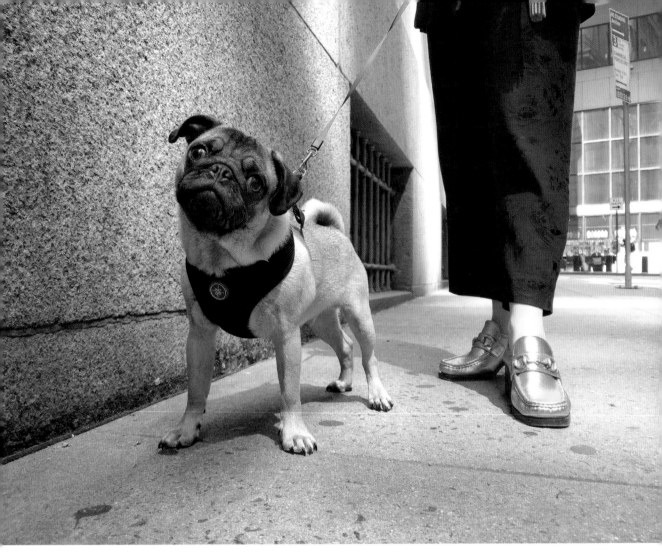

TREES

OFTEN SCULPTURAL, TREES ARE LANDMARKS LOADED WITH SYMBOLISM AND METAPHOR THAT ARE WORTHY OF PORTRAITS.

Give some thought to what it is about the tree that makes you want to photograph it in the first place. If you like its shape, then you will need to step back far enough to include it all in the frame.

Step back even farther if you like the way it looks within the landscape setting. Use your rule of thirds knowledge (see pages 14–15) to place the tree on one of the vertical lines to allow the tree space to breathe in the landscape around it.

For pictures in a woodland or forest setting, think about whether you want to focus on a single tree or perhaps the pattern of multiple trees together. Which tree is the main subject in your photo? Or do you want to give them equal prominence? Once you know these answers, you will be better placed to make a composition that tells your story.

Consider returning to a woodland to see the trees in a different season. Closely packed trees make for a congested view in the summer when they have all their leaves, but in the winter when they are stripped back to their naked branches, they might reveal more of their character and relationship to other trees around them.

You could make a project out of visiting the same tree over the course of a year or even many years, recording the changing seasons and the humans and animals that cross its path.

Look for moments when there is sunlight behind and shining through the tree to enhance the detail in the branches and make the leaves glow.

Using trees to frame a scene is another way of working with them. They can be used to create a foreground interest, which will frame an otherwise flat landscape.

Tap to focus on the tree and expose for the brightest area in the picture, usually the sky, to get the balance right across the scene. If the tree itself looks underexposed when you do this, fix it with Snapseed (see page 131).

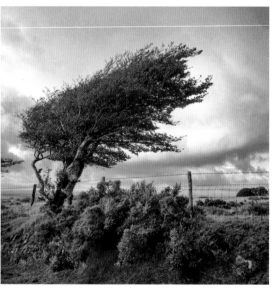

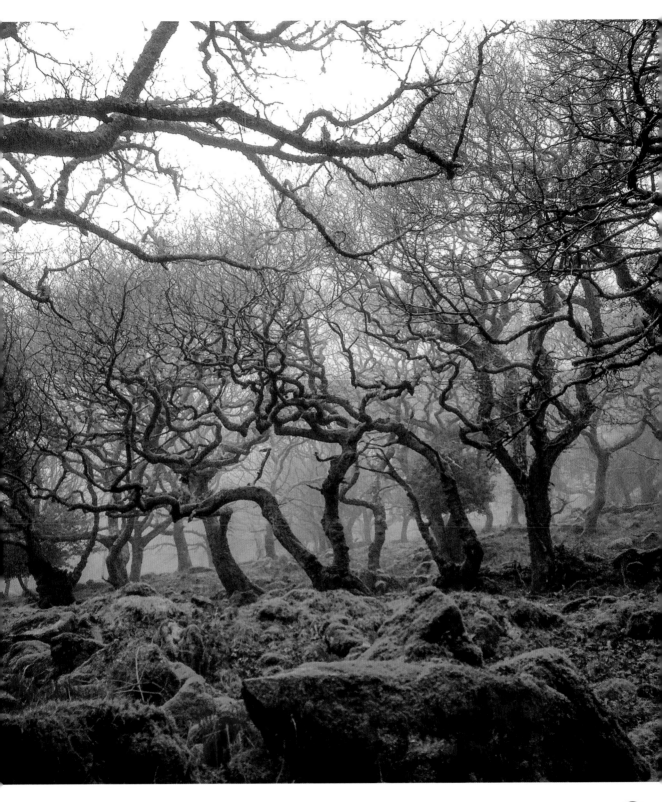

PLANTS AND FLOWERS

RECORDING THE RHYTHMS OF BIRTH, LIFE, AND DEATH PLAYING OUT IN THE MICROCOSM OF THE PLANT WORLD OFFERS AN ENDLESS SOURCE OF PHOTOGRAPHIC IMAGERY AND INSPIRATION.

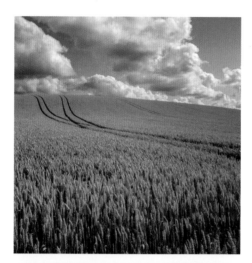

Exploring the textures, shapes, colors, and patterns that are abundant throughout nature may even set you on the path to pure abstraction. (See pages 108–109 for more on photographing abstract subjects.)

Drop to your knees—or even lie down—to look up at plants. From this vantage point, they will break the skyline, thus accentuating their height and color.

As always with smartphone photography, you can make the most of the fixed, wide-aperture lens by focusing on something in the foreground.

To mimic the shallow depth of field you get with a DSLR camera and lens, use a macro lens attachment. It will throw the background area of your image out of focus and separate the flower from the background. (For more about macro shooting, see pages 122–23)

Tap to focus on the center of the flower when you are shooting closer images; if you focus on the petals instead, it will feel awkward.

When you photograph plants en masse, such as carpets of bluebells, heather-covered hillsides, or fields of barley, experiment with focusing on the nearer plants for the detail, then try a few with the focus on the middle ground. You can decide at the editing stage which focal range best suits the overall scene.

GETTING CREATIVE

FROM THE ESSENTIAL SKILLS FOR LONG EXPOSURES, LIGHT TRAILS, AND MACRO PHOTOGRAPHY TO USEFUL TIPS FOR GETTING THE HANG OF FLAT LAYS, AND DISCOVERING THE SECRETS OF STILL-LIFE PHOTOS, HERE IS EVERYTHING YOU NEED TO UNLEASH YOUR INNER CREATIVE IN WAYS YOU MAY NOT HAVE THOUGHT POSSIBLE WITH A SMARTPHONE CAMERA.

ABSTRACTS

ABSTRACT PHOTOGRAPHY IS ABOUT YOUR UNIQUE, PERSONAL TAKE ON THE WORLD. THIS IS YOUR CHANCE TO THROW OFF THE SHACKLES OF CONVENTION AND GET A BIT ARTY. ANYTHING GOES: THERE IS NO RIGHT OR WRONG WAY TO APPROACH THIS, SO UNLEASH YOUR CREATIVITY AND SEE WHERE IT TAKES YOU.

Photography has always been associated with representation. The camera shows us things that exist or have existed, and so it helps our understanding of the world around us. Letting go of the urge to make literal representations of things allows us to make pictures that are interesting just because they exist in their own space as art objects.

Abstracts can potentially be found all around us. Train your eye to look at just the details; look for the texture in your built or natural environment, seek out patterns on the surface of everyday objects, and notice the way light and shade cast a definite but transitory mark on the walls and floors of the place you call home.

Look at building façades as part of a geometric pattern that is made up of lines, corners, and edges. Look out for reflected skies to create symmetry. Once you attune your creative eye, it becomes clear that abstract geometry is everywhere!

Break down street art and graffiti to just a series of lines and colors, by framing them so that there is little or no reference to the world outside the frame. Look for complementary colors and unexpected words and numbers to include as well.

Perhaps a starting point for your voyage into the unknown would be to simply remove all external references to your chosen subject. To do this, just frame up so that most or all of the subject's edges are outside the composition.

Next, seek out some hard lines that are juxtaposed with softer shapes or patterns. Try taking photos of the same thing from all sorts of angles; you may even decide to crop into them with an app later to make a whole new composition.

Remember all the earlier instructions about focusing and exposure; experiment with the same composition using different focal points by tapping in different areas of the frame to focus in unexpected places. You will have plenty to review later when deciding which combination works best for realizing your vision, so you can build on that knowledge next time.

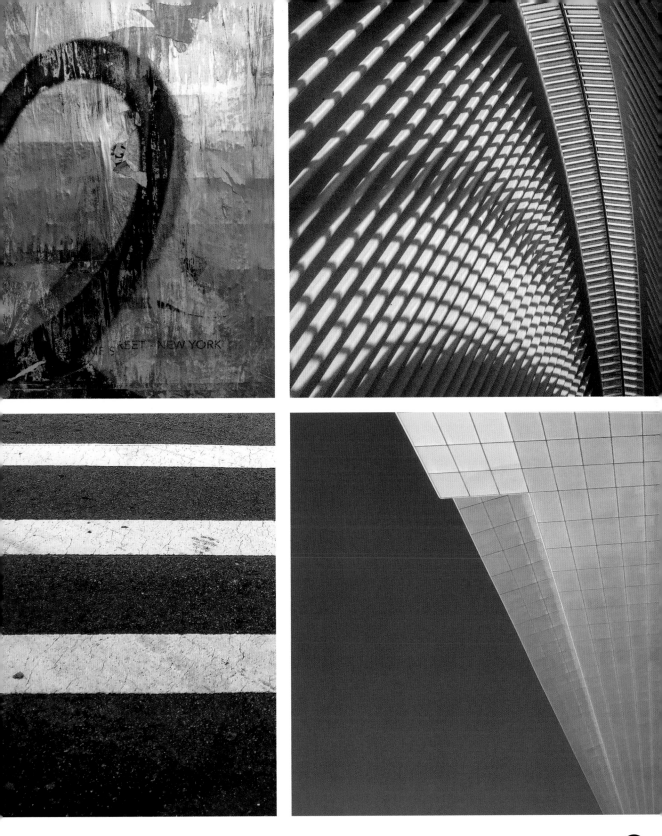

STILL LIFE: TELLING A STORY

STILL LIFE CAN BE AN OPPORTUNITY FOR GENUINE PERSONAL EXPRESSION. YOU WANT TO TELL A STORY, SO CHOOSE ITEMS THAT HAVE MEANING AND RESONANCE WITH YOU. THINK ABOUT EVERY SINGLE THING IN THE FRAME. WHAT IS EACH THING SAYING TO THE VIEWER? WHAT DOES ONE ITEM MEAN IN RELATION TO ANOTHER ITEM IN THE COMPOSITION?

This still life is very personal to me. I have had my old Polaroid Land Camera for decades. I have glued, taped, and soldered it together more times than I can count, and I still use it with affection to this day. When the peel-apart film for it was discontinued by Polaroid in 2008, I stockpiled hundreds of boxes of old film. I did the same with the Fuji film when they stopped making that too. My fridge still has a shelf full of out-of-date film for this camera, which I use sparingly nowadays so I can use my camera for as long as possible. Once this film has run out, the camera will never take another photo.

Here is a collection of a few polaroid moments that were captured on my beloved old workhorse. My glasses provide a double reference; they are about the everyday me, but they also relate to the act of seeing, an all-important part of photography!

Which possessions are most dear to you? If you wanted to give a sense of who you are, without using words, what would you include in your still life and how might a stranger interpret them?

Decide which item to make the focus of the composition and make sure it is sharp.

Tap to focus on different parts of the main object in your composition if it is large, so you can decide which works best later on when you come to edit it.

Try making dynamic compositions with diagonals and leading lines, and think about working with color in a way that complements rather than detracts from the scene.

STILL-LIFE SHOOTING AND DEPTH OF FIELD

GETTING THAT HIGHLY SOUGHT-AFTER EFFECT OF A SHALLOW DEPTH OF FIELD IS EASILY ACHIEVED IN STILL-LIFE PHOTOGRAPHS.

This is the moment for the smartphone's fast lens to shine. With that wide aperture of somewhere between f1.7 to f2.2, it will really come into its own.

When shooting close-ups, that short distance between your camera lens and the subject will give you a shallow depth of field and a blurred background.

Experiment with moving your subject away from the background to blur it out. If you move it too far away, the continuous area of background may need to be very large to compensate, but a great distance should not be necessary—you will find the sweet spot very quickly and easily.

In the illustration opposite you can see that objects photographed up close in the foreground are sharp, throwing the middle ground and background artfully out of focus. When using the same framing, but this time tapping to focus on the middle ground, the sharp area extends from the middle ground and takes in everything beyond it in the background as well, but note that the foreground is no longer sharp.

THREE'S COMPANY WITH THE RULE OF ODDS

There is a compositional theory that your picture will have more balance and harmony if you surround your subject with an object on either side, thus creating a set of three and an odd number. This is very subjective, but do give it a try when you are working on a still life. The rule only applies to small odd numbers like three and five; any more than this and the brain doesn't try as hard to group things together, instead seeing the whole scene rather as a mass of objects.

You can use this rule to play around with introducing lines and triangles into your compositions too.

FOREGROUND
Only the foremost fig is sharp when the foreground is selected as the focal point.

FORE-MID
When the second closest fig (in the mid-foreground) is the focal point, the mid-ground fig is fairly sharp too.

MID-GROUND
Only the middle fig is sharp when the middle ground is the focal point.

BACK-MID
The fig in the mid-background is the only one that is sharp when the middle background is the focal point.

BACKGROUND
When the fig in the background is the focal point, the mid-background fig is fairly sharp too.

FLAT LAYS AND BIRD'S-EYE VIEWS

FLAT LAYS ARE A FORM OF STILL-LIFE COMPOSITION, BUT INSTEAD OF THE USUAL FRONT OR SIDE VIEW, THE FLAT LAY TAKES A BIRD'S-EYE VIEW OF THE SCENE FROM DIRECTLY OVERHEAD. FLAT LAYS MAY FEATURE FOOD, FLOWERS, RETAIL PRODUCTS, OUTFITS, OR ANYTHING ELSE THAT COMES TO MIND.

As these examples tend to involve tight compositions, it will enhance the scene if you make sure that the objects are relatable, so perhaps use similar colors and objects that are connected thematically. Keep the composition loose and not too tightly packed together—this sort of composition needs room to breathe. Try to keep an equal amount of space around the objects for an overall balance.

Clean and simple backgrounds for flat lays are essential—avoid busy patterns and shapes at all costs! Lay your objects on uncluttered surfaces like wooden floors, tabletops, wooden benches, marble slabs, pieces of slate, ceramic tiles, clean bed linen, towels, and tablecloths, and even rugs or mats.

Avoid distortion by ensuring that your phone camera is level on both the horizontal and vertical planes, and that the camera lens is exactly parallel to the surface you are shooting. This is best done by standing on a stool or chair to get a good distance away from the subject.

Many camera apps for smartphones come with a tilt-meter that will help you get everything lined up perfectly on both planes.

FOOD PHOTOGRAPHY

When photographing food, consider its dimensions first. If you are taking pictures of a cherry pie, it will probably look best from directly above. Tall stacks of food will need to be photographed from the side to appreciate their height. For a cocktail in a fancy glass, you might want a bit of the surface and also the side, so opt for a 45° angle to take it all in.

Think about your composition, what is in the frame, and what should be left out. Does that fork add to the image? If not, take it out. Keep it minimal and clean so that the photos are just about the food.

Try to use the natural light if possible, so in restaurants ask for a table by the window if you want to shoot your food. You can do wonders with the editing apps if the lighting is less than perfect, so don't despair!

STILL LIFE: SHOWING OFF PRODUCTS

IF YOU WANT TO PHOTOGRAPH THINGS YOU HAVE MADE, SELL, OR JUST PLAIN ADORE, YOU WILL WANT THEM TO LOOK THEIR BEST! HERE ARE SOME IDEAS FOR MAKING THE MOST OF THE SUBJECT, WHATEVER IT MAY BE…

Lighting is a key factor in making good still-life pictures. Try to work with natural light whenever possible. If you are using window light, consider covering the window with some translucent white fabric such as muslin (cheesecloth), curtain nets, or voile to soften the light. Experiment with working at different times of day and close to windows that face different directions; north-facing will usually provide the smoothest light, but a sunny south-facing window can give you drama and high contrast. For more about diffusing light, see page 56.

Do not resort to using your device's flash, because it will cause high spots—bright areas of reflected light—where the flash has bounced off any shiny and reflective surfaces. You will have trouble controlling the shadows too, and to make matters worse, it will probably bleach the subject out and make it look unappealing.

If you need to boost your lighting, you could try out a ring flash for a more diffused light source. You can find out more about ring lights on page 57.

If you are serious about still-life photography and have the space available, create a makeshift studio with a small piece of white board (cardboard, foam board, or even paper will do). This cheap and easy reflector will bounce light back at the subject and help you control the shadows. Learn more about reflectors on page 58.

Your fixed smartphone lens is perfect for this kind of shooting. It has a good wide aperture to allow lots of light in. Do not be tempted to zoom in—digital zoom is horrible! Move closer or farther away to alter your framing, or experiment with a telephoto lens attachment, which has the added potential for that sought-after background blur.

Try out a variety of angles from which to photograph your subject, get mobile and look from lots of different viewpoints, and take tons of photos, so that you can decide afterward in the editing stage which ones work best for you.

LONG EXPOSURES OF WATER
LONG-EXPOSURE PHOTOGRAPHY IS ESSENTIALLY LETTING THE SHUTTER STAY OPEN FOR MANY SECONDS RATHER THAN THE USUAL MERE FRACTIONS OF SECONDS.

When you are taking photos of water, long exposures will result in eerily beautiful, misty water effects. Note that the camera cannot move at all during the exposure, so a tripod or other stable base is essential. For more about tripods, see pages 32 and 142.

Long exposures don't work well in bright light—it will just burn out the image into a big bright mess. Try shooting on overcast days or look for waterfalls in wooded valleys to help reduce the light. A good place to start is with a two- or six-second shutter speed to smooth out the water.

Look for something like a rock, tree root, boat, or bridge to give some stability to the scene. The rush of the moving water will look more impressive set against the stillness of the static object in your composition. Ideally, trigger the shutter without any pressure from your hands.

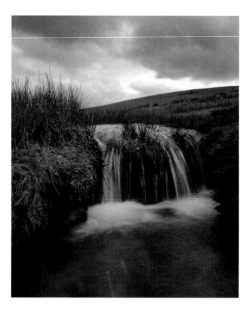

Here are some options:

▶ Set your camera to self-timer and then step away from it so that it has time to stop wobbling from your touch before the shutter is triggered.

▶ If you have a headphone set with a volume control, plug it in and press the volume button on the headphones to activate the shutter release.

▶ Invest in a Bluetooth remote shutter release gadget and work like a pro. These tiny tools can be picked up very cheaply and they are a game changer for long exposures!

▶ Lastly, turn your flash off. As daylight is already bright, you will need to keep the amount of light hitting the sensor as low as possible. You are already trying to avoid overexposing, so don't make it impossible by firing off a flash. Tap the flash symbol (the lightning bolt) on your screen to turn it on and off.

ANDROID PRO MODE
On Android devices, you can switch to Pro Mode in your camera settings (see Light Trails on pages 120–21 for more on this) to adjust shutter speed settings, exposure compensation, and ISO.

SLOW SHUTTER CAM APP (IOS ONLY)
iPhones are currently not capable of taking long exposures with the native camera, but you can get apps that mimic the effect by taking multiple photos and blending them all together on screen as you watch. I use

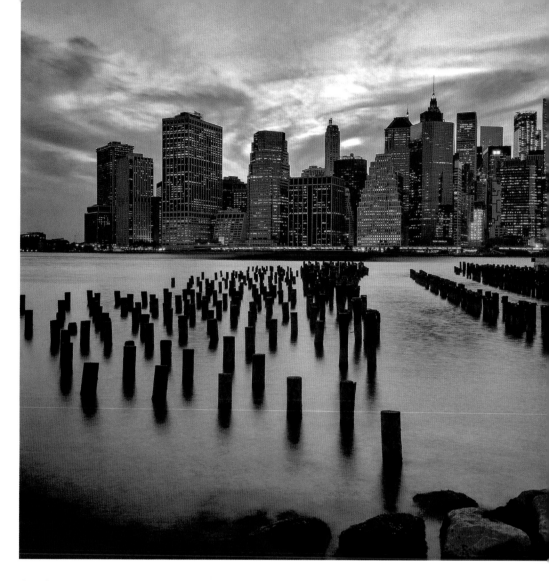

the Slow Shutter Cam app, which costs next to nothing. This app affords you a live view of the exposures stacking up during the exposure, a helpful tool as you search for the sweet spot which could be a shutter speed of 2–30 seconds, depending on how much light you have in the scene. With this app, you can alter the amount of blur visible; for example, you may need to do this to balance the contrast between the desirable water blur and the less desirable blur of leaves on trees blowing in the wind.

Open the Slow Shutter Cam app and click on the gear wheel in the bottom left of the screen to access the settings.

Choose Capture Mode—Motion Blur.

Set the Blur Strength slider to somewhere in the medium range for the first go.

Set your Shutter Speed slider to around 15 seconds to start with; you can change it for the next one.

Set your ISO slider to the far left, which is the lowest ISO number possible. This will keep any low-light noise (i.e. image graininess) issues to a minimum.

Tap anywhere on the screen outside the control window and it will clear the screen ready for the photo.

Press the round shutter button in the center at the bottom of your screen.

LIGHT TRAILS

ANOTHER GREAT WAY TO WORK WITH LONG EXPOSURES AT NIGHT IS TO MAKE LIGHT TRAILS. THIS IS A PROJECT THAT IS GOING TO NEED SOME FORWARD PLANNING.

Find safe locations where you can see cars passing in two directions. From a safety point of view, if you can position yourself behind a low wall, then do so; wear something bright and reflective just in case, and never set up in a road. If you can compose a shot that includes the changing colors of the traffic lights, then you are on to a winner. If you frame up to capture cars waiting for their turn to cross a junction, you may get lucky and freeze a single car within the light trails for bonus skill points!

As with any long-exposure photo, a stable base is a must-have. The little tripods for smartphones are not always the best solution on their own—I want my camera much higher than ground level for this sort of photography because I don't want to be looking at the underside of passing cars! Setting up your tripod on a wall or gate post will do the trick nicely, but sometimes you need to get creative with your solutions. My favorite trick here is to use one of the bendable tripods designed for smartphones, such as a Joby GorillaPod Pro, which I twist onto the top of a normal size camera tripod. Then I use some strapping or duct tape to secure it in place. There... I fixed it!

Note that duct tape is something I always have at hand in various sizes; I can secure, repair, or build anything with that stuff, but I digress...

Many of the low-light apps have a few seconds' delay after you press the shutter, which is adjustable, to allow the camera to settle before it starts recording the exposure. This is a really useful function when it comes to capturing light trails.

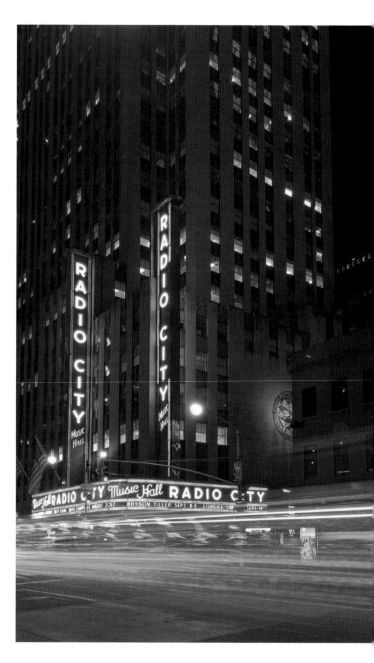

Otherwise check out the options listed in Long Exposures of Water (see pages 118–19.)

For more about tripods and Bluetooth remotes, see the Kit List on page 142.

ANDROID PRO MODE

On Android devices, you can switch to Pro Mode in your camera settings to access the shutter speed controls. Try shutter speeds of 2–30 seconds, depending on how much light you have in the scene. You won't be able to see what the effect you're getting is until afterward, so it will take some trial and error to get right. If your pictures are coming out too bright, you need to reduce the amount of light getting in, so set your ISO as low as possible—below 100 if you can. If they are still too bright, you can try to push your exposure compensation slider to underexpose even further. You can easily change all these settings in Pro Mode— simply tap the double lines in your camera screen to open up the advanced settings. Some Androids do not go lower than ISO 100, which may put a dampener on your light trail ambitions for now. I haven't found a suitable app for this at time of writing, but there are a few with promise if they can sort out their glitches, so keep an eye out for long exposure apps available for Androids.

SLOW SHUTTER CAM APP (iOS ONLY)

As mentioned on the previous spread, iPhones are currently not able to take long exposures with the native camera. To get around this limitation, I use the Slow Shutter Cam app to replicate the effect.

Open the app and click on the gear wheel at the bottom left of the screen to access the settings.

Choose Capture Mode—Light Trail.

Set the light sensitivity slider to somewhere in the middle, perhaps $1/8$ for the first go—but do experiment with moving it later.

Set your Shutter Speed slider to around 15 seconds to start with; you can change it for the next one.

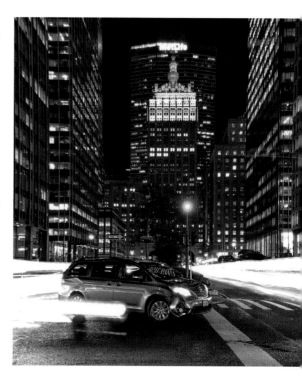

Set your ISO slider to the far left, which is the lowest ISO number possible. This will keep the low-light noise (i.e. image graininess) problems to a minimum. Don't select Auto ISO, because the app can only guess at what you are trying to do. It's a much better idea to take control to achieve your intentions instead!

Tap anywhere on the screen outside the control window and it will clear the screen ready for the photo.

Press the round shutter button in the center at the bottom of your screen.

Stand back and watch the magic! Slow Shutter Cam has a live view of the exposures stacking up during the exposure. My favorite part of the whole exercise is watching the trails appear on the screen.

For more on the Slow Shutter Cam app and its settings, see Long Exposures of Water on pages 118–19.

MACRO

MACRO PHOTOGRAPHY ALLOWS YOU TO GET VERY CLOSE TO YOUR SUBJECTS. IT IS FUN TO DO AND CAN REVEAL DETAIL YOU WOULD NEVER SEE WITH THE NAKED EYE.

LENSES

There are a few considerations when investing in a macro lens: the quality of the glass, how much edge-to-edge clarity you will get, and how much lens distortion you can expect. You will need to weigh these factors against cost (and your budget), and buy the best macro lens you can afford. I have a set of "pro" macro lenses by Olloclip with three different attachments that offer 7x, 14x, and 21x magnification respectively.

Start with the lower magnification, such as the 7x, first because it is easier to handle and less prone to blurring. You can work your way up to the 14x and 21x magnification as you get some experience under your belt.

Macro photography on a smartphone can be quite headache-inducing; the slightest movement will be magnified and trying to get your camera lens to align with the tiny thing you are trying to photograph can be cause for serious eye and brain strain.

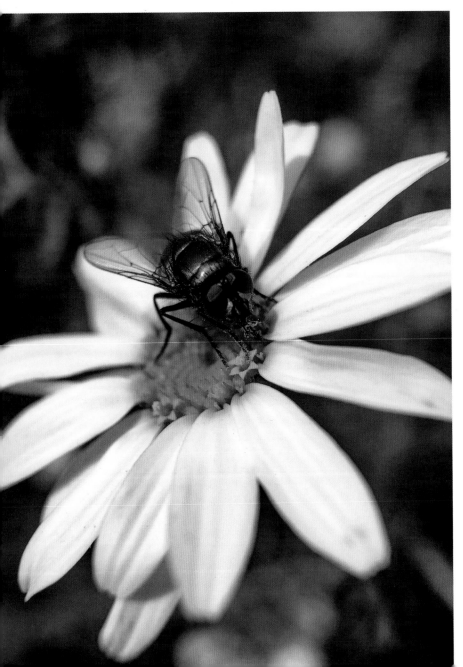

SHOOTING SMALL

Bugs are the perfect subject for getting your macro attachment out. Use something in the range of a 7x lens to take pictures of marvelous bugs and beetles while still (possibly) hand-holding. Hand-holding may be all the more necessary when you consider the challenge involved in getting bugs to fly in and settle right where you set up your tripod, because that rarely happens! Instead, I crack out my Manfrotto monopod for this and often get better results.

The difficulty with shooting bugs with a macro lens attachment on a smartphone is the issue of working distance (the space between the end of the lens and the subject). The challenge is that with most macro lenses available for smartphone shooting, the working distance is extremely short. Because of this, the critter is often disturbed long before you have composed and focused the scene. Patience and a huge element of luck will pay off, so stick with it!

At 14x or 21x magnification, a tripod is essential, so aim to photograph static objects with these magnifications. Forget working outdoors with a lens of these greater magnifications; anything that moves or sways even a little bit in the breeze will be nigh on impossible to compose within the frame, let alone capture in focus.

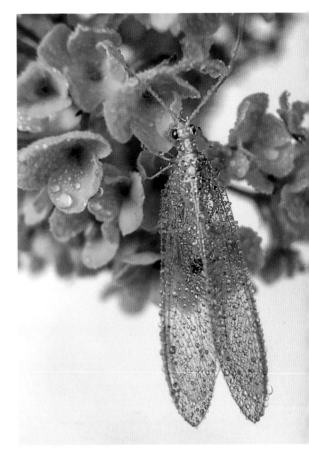

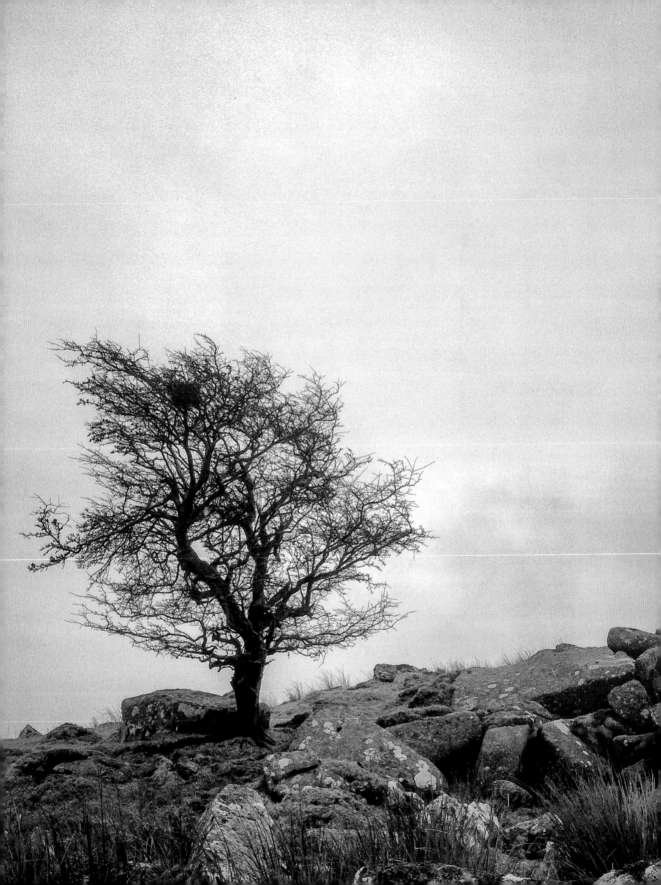

IN THE LIGHTROOM
AND BEYOND

1 EDITING WITH APPS

WHEN EDITING PHOTOS, THERE IS A CONFUSING ARRAY OF APPS OUT THERE. THIS CHAPTER COVERS THE ESSENTIAL TOOLS NEEDED TO CORRECT COMMON ISSUES, FROM WONKY BUILDINGS TO FLAT, LIFELESS IMAGES. CASE STUDIES AND STEP-BY-STEP GUIDES WILL EXPLAIN HOW TO MAKE YOUR PHOTOS GREAT USING APPS AND A TESTED METHOD TO EDIT AND PRINT.

A FEW THOUGHTS ON EDITING WISELY

WHEN I LEARNED TO TAKE PHOTOS AT COLLEGE, I ALSO LEARNT HOW TO PROCESS AND PRINT THEM IN A DARKROOM. IN THIS SETTING I LEARNED ALL ABOUT MASTER PHOTOGRAPHERS AND PRINTERS LIKE ANSEL ADAMS. WHAT I TOOK MOST FROM STUDYING THE MASTERS WAS THAT TAKING THE PHOTO WAS ONLY THE FIRST STAGE OF THE PROCESS.

Once in the darkroom, the photo would be perfected to heighten the sense of the extraordinary that the photographer wanted to share with their audience. There you might "dodge and burn" your photos, darkening or lightening them to enhance areas and help balance out the tonal range overall. This is considered a normal part of the art of making photographs; this art form still exists, it just happens with apps in a digital lightroom instead of in a chemical darkroom.

Don't hesitate to make your photograph sing like the scene you saw when you pressed the shutter. Sometimes we end up with pictures straight out of the camera that don't bear any resemblance to the scene we remember, but this is where editing comes into play. It's a vital part of the process, so you need to hone these skills too.

"Do less, in order to do more" is the motto I apply throughout all aspects of my creative career. It was first uttered by German-American artist and educator Josef Albers to his Bauhaus students, and I still feel it is the most important consideration in the photo-editing phase. Edit wisely and sparingly, both to reveal the beauty in an image and to enhance a great shot. Don't let your photos be defined by the apps and filters you choose; use them with a light touch and let the picture's inner beauty shine through.

I used to shoot with a DSLR camera and spend weeks processing on a computer, using programs that took years to learn. But now, I love the freedom to shoot and edit on my phone anywhere. If I have a spare minute between meetings or I am sitting on a train, I use the time on my phone to edit photos. I never have a wasted minute anymore; waiting in line for something is a great chance to work on photos on my phone. It's life changing!

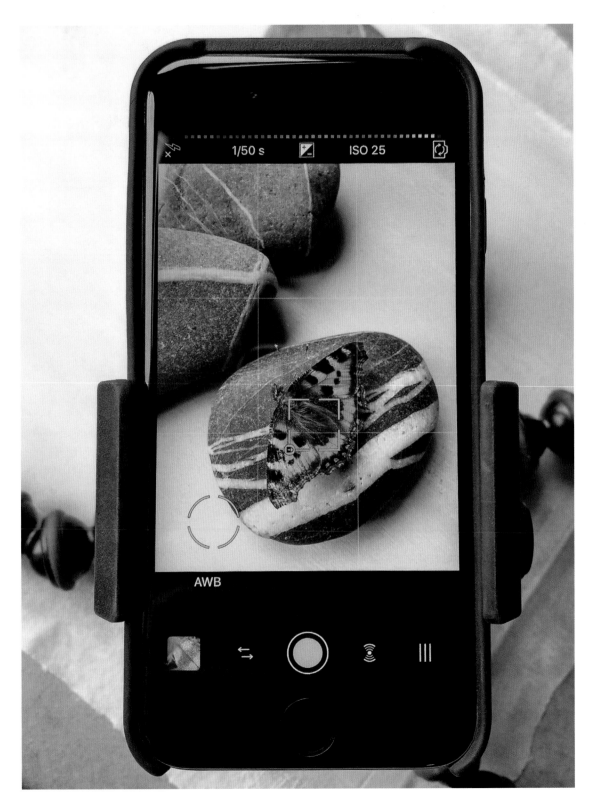

FIXING LINES AND ANGLES WITH SKRWT

SKRWT IS MY GO-TO APP FOR FIXING ISSUES WITH LEANING BUILDINGS AND ANY WEIRD ANGLES THAT APPEAR IN MY PHOTOS.

▶ To start, tap on the grid icon and select one of the grids to help line things up.

▶ The Lens Correction tool will fix any lens distortion from your smartphone lens—use the Mobile setting for this unless you have shot with a lens attachment; in which case, choose the appropriate lens correction option for the job in hand.

▶ Level the horizon line with the Rotation tool by swiping left or right to make your adjustments. Double-tap to set it back to zero and start again if needed.

▶ There is an Autocrop feature in play here that will automatically crop away the areas of the image that sit outside the usual frame shape. You can turn this feature off and view the whole image as you work if you like though—it's a personal preference thing!

▶ Vertical corrections are where the leaning lines are corrected. Vertical corrections may have the effect of compressing some of the details in the foreground, making them look smaller, but this can be fixed in the next stage by selecting the Ratio tool. This allows you to stretch it back out if necessary.

▶ If the Autocrop feature has been disabled, the image will need to be cropped manually. Select the Crop tool for this, choosing either the fixed ratio or free ratio option, tap with two fingers, and use them to drag the frame around the image; tap on a corner to drag the frame bigger or smaller. A green corner suggests there is more image information to

use; when the corner goes red, it means that there is no more image to work with, so move the edge until it goes green again.

SAVING

▶ Select the Bank option to save the work you've done so far into a solid layer before moving onto another correction.

▶ Bear in mind that there is a Full Reset option, or the option to start again from the bank level you last saved.

▶ Finally, save a *copy* of the image—over-writing the original means you can't revisit the initial image later. You never know what you may want to do with the image later, so keep your options open!

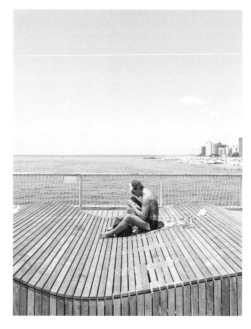

SATURATION (STRENGTH OF COLOR)

Most smartphones automatically boost saturation when you take a photo. This can look punchy, but it also looks fake! Decide if the image has that oversaturated, unrealistic look, which will be especially noticeable in the green. Ask yourself: did the grass really look that color? Turn the saturation down slightly now, so that you are not overlaying even more fakery onto it to begin with. Make it look realistic for now, and trust that you can boost the saturation again later with just the right amount. It will be like a final layer of varnish to enhance your masterpiece at the end!

BLACK AND WHITE WITH VSCO

I prefer to shoot everything in color and then work with the VSCO app's Black and White filters later to change my image from color to monochrome. My favorite black and white filter in VSCO for portrait and street photography is the FN16 Filter which replicates the long-gone, but not forgotten, Fuji Neopan 1600 film for 35mm cameras. This was much-beloved by street photographers for its contrasty lo-fi look and ability to shoot hand-held in very low light conditions. Play with the contrast slightly to see if you can make gains, as color photos converted to black and white are often improved by a bit more contrast.

THE EDITING PROCESS AND SNAPSEED

LET'S LOOK AT HOW TO GIVE YOUR PICTURE SOME FINESSE DURING THE EDITING PROCESS. THERE ARE MANY GREAT APPS OUT THERE TO HELP IMPROVE YOUR PHOTOS, INCLUDING EDITING FEATURES PACKAGED WITH POPULAR APPS SUCH AS INSTAGRAM.

Personally, I favor the Snapseed app, because it allows you to do so many clever things in one place, and it is available for free for both iOS and Android. It's easy and intuitive to use, with a helpful tutorial for those using the app for the first time. Once you've familiarized yourself with navigating the app, here is a list of my essential Snapseed workflow tools:

▶ Begin any edit with the Rotate tool. If your horizon is a bit wonky, this is the tool to sort it out.

▶ Use the Crop tool next. You can move the edges of the image to crop to one of the aspect ratio presets or make a free crop. This step isn't always needed but is useful to tidy up a composition.

▶ For precision adjustments, use the Brush tool and work in smaller areas. There are several brushes here, including an Exposure and a Saturation tool, but my favorite is the Dodge and Burn tool. The Dodge tool brightens by adding light, so move toward the + sign for this effect, whereas the Burn tool darkens by decreasing the light, so move toward the - sign for this. My advice when using the Dodge and Burn brush is to use it at a strength of +5 rather than +10 to keep the changes small and minimal—subtlety is key!

▶ For larger area adjustments, use the Selective tool. Tap on an area that needs adjusting and a small "B" in a blue circle will appear. Swipe up and down to reveal the adjustments menu. I primarily work with Brightness here. Using a pinch movement on the touch screen, you will see a red blush appear across the area to be affected by the adjustment. Alter the size of the area affected by any change you make by pinching in or out. Swipe left or right to increase or decrease the tool effect. Notice the + (or) - symbol with a number at the top of screen—it changes as adjustments are made. Try to keep that number low, to avoid the image looking overprocessed, especially after the cumulative effect of multiple adjustments is in force.

TUNE IMAGE

Tune Image offers a menu of useful tools; swipe up to reveal them.

▶ Boost the overall **Brightness** here, but be careful not to blow out your highlights; the aforementioned Selective tool is often the better option.

▶ The **Ambience** tool works a little magic by giving images with a high dynamic range a bit of a boost, but use it sparingly, ideally between +5 and +30. It adds a small lift to the overall vibrancy and optimizes the shadows and highlights. The result is like the HDR effect, but using the Ambience tool is less destructive and far more pleasing to the eye.

▶ If the **Highlights and Shadows** need a small amount of attention, then they can be tweaked here. But remember, less is more!

▶ If the picture looks soft, sharpen it with the **Detail** tools. Swipe to reveal the Sharpening tool, which adds a tiny amount of extra contrast to the edge details to make it appear sharper. Use it sparingly because it can quickly make an image look overcooked.

EDITING TIP

Working in any of the Tools screens, you can zoom in or out with a pinch movement (pinch two fingertips together on the touchscreen). This will open a blue navigation frame that you can drag around the picture with your finger.

RAW FILES

There is a facility to develop RAW files on Snapseed too. With RAW developing, you can adjust exposure and white balance, among other things. If you do make alterations here, tick to accept the RAW file changes and you will enter the standard editing area.

EDITABLE LAYERS

Snapseed has a clever feature that saves all the edits made in separate layers. This means that you can go back and make adjustments or even delete individual layers, which is particularly useful at the end of the edit when the cumulative effect of the edits is visible.

SNAPSEED TIP

When making lighting adjustments, try not to add light to areas that would not naturally have light in the scene, or viewers will be wondering where the light comes from!

SKY AND LANDSCAPE EXPOSURE BALANCING

If you have followed my previous instructions on exposing for a bright sky, you will have photos with dark areas that need fixing now. Here's how…

Using the Selective tool, pinch out an area of the dark shadow that needs brightening; ensure that you don't include the sky in the selected area (denoted as red blush) and then adjust the brightness. This will give the scene the correct balance between the bright sky detail and the shadows as your eye saw it.

EDITING CASE STUDY 1

IN THE ORIGINAL UNALTERED PHOTOGRAPH, THE USE OF A SUPER WIDE-ANGLE LENS ATTACHMENT MEANS THE LENS DISTORTION IS STRONG, CAUSING THE BUILDINGS TO LEAN TOWARD EACH OTHER, AND THE APPEARANCE OF A SLIGHT BULGE IN THE CENTER OF THE IMAGE.

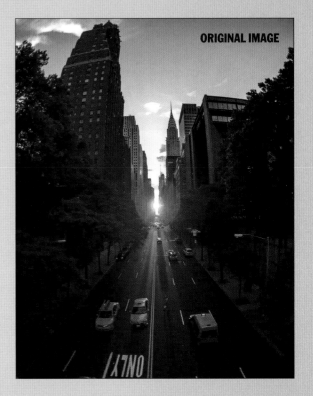

ORIGINAL IMAGE

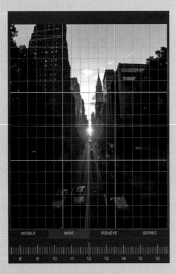

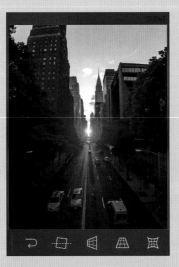

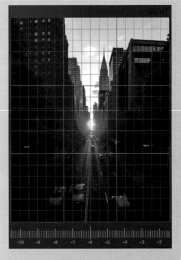

1 In the SKRWT app, I corrected the converging verticals with the Lens Correction tool, setting the "wide" slider to +12.

2 The Chrysler Building in New York still appears to be leaning to the left, so I used the Straighten tool to correct the angle very slightly.

3 With the Vertical Correction tool, I dragged the slider to -6 until the lines made by the columns of the left-side building's windows are straight. This cropped a large part of the image away but that was okay.

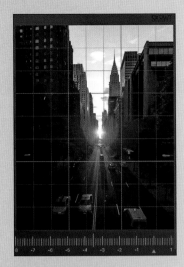

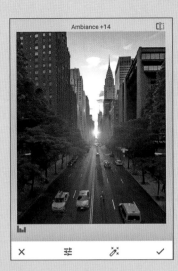

5 I saved a copy of the image, and opened it in the Snapseed app. With the Tune Image tool, I swiped down to reveal the menu and increased the Ambience by +14 to boost the colors and saturation very slightly.

4 The Horizontal Correction tool at -3.5 pulled the roof top of the right-side building into a better line.

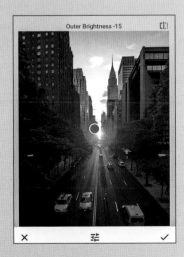

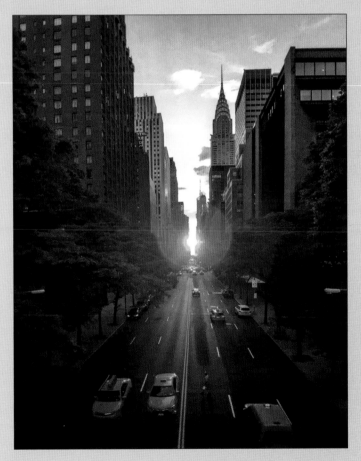

6 To add depth I used the Vignette tool, setting the outer brightness to -15 for a tiny overall adjustment

7 Finally, I opened the file in Instagram and applied a small amount of the Luxe filter to the image, which gave it an extra boost.

EDITING CASE STUDY 2

IN THIS ORIGINAL UNALTERED PHOTOGRAPH, THE SKY HAS BEEN EXPOSED TO ENSURE THERE ARE NO BURNT-OUT AREAS AND THE DETAIL IS PRESERVED, BUT THIS MEANS BOTH THE TREE AND THE FERNS ARE UNDEREXPOSED.

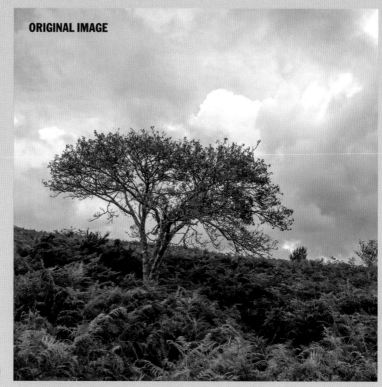

ORIGINAL IMAGE

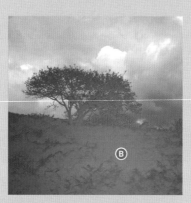

1 Using Snapseed's Selective tool, I tapped to make a brightness adjustment, and pinched out a selection covering the entire area of land and the tree, shown here as a red blush.

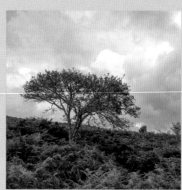

2 Swiping right, I increased the brightness by a factor of +20.

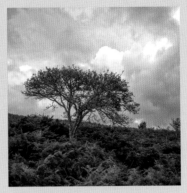

3 I selected the Saturation brush from the Brush tools and tapped the down arrow to set its strength to +5. A single stroke across the red berries in the tree gave them a small saturation boost.

4 The photo looked a bit flat overall, so using the Vignette tool with a light touch, I swiped left to reduce the outer brightness to -30.

5 I then used the Tonal Contrast tool to overlay contrast across the low, mid-, and high tones. I first swiped up to reset the low and mid-tones back to 0, then adjusted the high tones to +25 to give the clouds some definition.

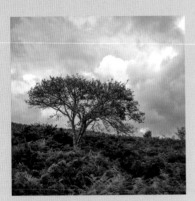

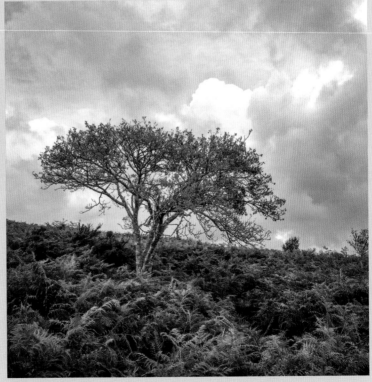

6 I selected the Tune Image tool, swiped down to reveal the menu, and added a small amount of Ambience to the picture; in this case, just by a factor of +15.

7 Finally, in Instagram, I added the Luxe filter at +35 to give the image an extra boost and added some light and warmth with the Rise filter, dialed back to +45.

PRINTS ON PAPER

THE FINAL PHASE IN YOUR IMAGE-MAKING SHOULD BE THE JOURNEY FROM SCREEN TO HAND. DON'T BE TEMPTED TO LEAVE YOUR BEST PICTURES LANGUISHING ON YOUR PHONE.

Instagram, Facebook, Pinterest, and Flickr, among others, are wonderful platforms for image-sharing with a wide and diverse audience. But social media-sharing alone doesn't really do the image justice. It is amazing that your photo can be seen on a screen thousands of miles away by millions of people, but most viewers will only enjoy it for a fleeting moment before swiping or scrolling to the next image in their feed.

While it might be more difficult to get an audience of a similar size to see a print, there is no substitute for holding a print and appreciating the hard work invested in crafting the image. As the image has enough pixels to be seen at way beyond the size restrictions of the screen, it is worth exploring the possibilities of enlarging your photos into printed form. I have printed my smartphone photos for exhibition at 10 inches (25 cm) square, to the amazement of all who saw them when they realized that the images had come from a smartphone.

I love hanging my photos on walls, framing them as gifts, exhibiting them in galleries, and putting them in books, cards, and calendars. Owning an inkjet printer isn't a prerequisite for making prints; there are boundless options for online ordering but they lack any real control over the final color and quality. Personally, I like to print my own pictures. It is easy to do and so rewarding to have control of the image from start to finish. Even a cheap, entry-level inkjet printer, in the right hands, with the right ink and paper, can make a lovely job of your images.

When it comes to paper, there are endless choices, and I have tried them all over the decades, so let me share my preferences with you. I have worked with Fotospeed papers for years; the company makes top-quality paper and knows their business inside out. My passion for their paper has grown even more since they introduced a range of square-format photographic papers, meaning that I don't have to cut off a third of a sheet of paper and throw it away when I make square prints now—a more cost-effective option for smartphone shooters like me!

I prefer the feel of a textured paper and opt for one that feels like traditional watercolor paper for printing my photos onto. My favorite paper is Fotospeed's Platinum Etching paper. At 285gsm it has a proper weight to it, and is 100% acid-free, so when I use it with my Epson pigment inks, I know that the color will last and be true to life. But the main reason I love it, is that it has a velvety textured matte finish that looks lovely in a frame. My glossy paper choice is Fotospeed's Platinum Baryta 300gsm, which has a lovely smooth surface and is particularly striking with my black-and-white images. I always have several boxes of PF Lustre 275gsm paper from Fotospeed's photo-quality range on the go, just because it is so reliable and easy to work with. The Fotospeed paper range is compatible with both dye and pigment inks, and is available worldwide.

Getting the color right between screen and print can be a challenge without the right support, so I make use of Fotospeed's Free Custom ICC profiling service that comes with their papers. This way, I am sure that the paper and printer are properly calibrated to easily achieve accurate, faithful color and black-and-white prints every time.

Don't leave your images as a collection of pixels: embrace printmaking as part of your craft and realize your images as something physical. Get in the habit of releasing your images from digital storage and allow other people to enjoy and appreciate your hard work and creativity by printing an image that will be a source of pride every time you walk past it on the wall!

NUTS AND BOLTS

THE WORLD OF DIGITAL PHOTOGRAPHY IS FILLED WITH JARGON THAT CAN SEEM A LITTLE IMPENETRABLE AT FIRST. THE FOLLOWING INFORMATION WILL DEMYSTIFY THE KEY TECH-BASED TERMS AND PROCESSES PHOTOGRAPHERS USE REGULARLY. ALSO OFFERED IS A USEFUL KIT LIST FOR THOSE LOOKING TO GO BEYOND THE BASIC SMARTPHONE CAMERA SET-UP.

RESOLUTION AND MEGAPIXELS

THINK OF A DIGITAL PHOTOGRAPH AS A MOSAIC: IT IS MADE UP OF MILLIONS OF TINY, COLORED TILES THAT FORM THE IMAGE WHEN VIEWED AS A WHOLE.

Through its lens, a camera takes a scene made up of light and shade, and transforms all of that information into pixels—the tiny picture elements that make up the whole image. Pixels can be round or square, and the number of pixels in your photograph is generally referred to as the resolution.

Resolution is the detail an image holds. It is typically measured as the number of pixels per inch (ppi). It is also expressed as two numbers, for example 4032 x 3024. This means that in a particular image, there are 4032 pixels from left to right and 3024 pixels from top to bottom.

The number of pixels that your camera can capture in a single photograph is usually measured in megapixels. One megapixel (1MP) is equal to one million pixels. The detail available in a photo is dependent on the number of pixels present; the more pixels in the photo, the more detail there will be. Your smartphone camera shoots at least 8MP photos, which will be good enough to print your lovely pictures and frame them (see Prints on Paper on page 136).

FILE TYPES, FILE SIZES, AND COMPRESSION

WHEN YOU MAKE A PHOTOGRAPH AND YOUR CAMERA SAVES IT, IT COMPRESSES THE FILE.

This makes it easier to handle and smaller so that it doesn't take up too much valuable storage space on your phone. You may think that this is a great thing if, like me, your phone is always on the verge of being full and you frequently get messages telling you to free up some storage space. So saving images in small sizes is a good thing, isn't it? Well no. Not always. There are some very important things that you need to know about how your files are saved, the different file saving options, and the differences between them. The choices you make in your camera settings about file formats will have important repercussions on what you can do with your photos later, especially if you want to print your images. Without this knowledge you could end up ruining your picture quality, so no skimming over this next bit please!

You may not have given it much thought before, but the size of the photo you take and save has a direct relationship with what you can do with it afterward. There are file size considerations to bear in mind if you intend to print the photo; the greater the number of pixels in your picture, the bigger you can print it without a loss of quality.

A factor to take into account is the resolution of your image. Images that are intended for viewing online have a small file size (made possible by their small image resolution), so that they can be uploaded swiftly. As you know, resolution is the number of pixels per inch that make up the overall image. The fewer the pixels, the smaller the file size, so an image for screen viewing is usually set to a standard 72 pixels (of colored information) per inch.

I shoot with an iPhone and an HTC Android that both produce impressive 12MP files. This is especially impressive because this is the same size file that I could produce with my first professional Canon DSLR, which I bought at great expense not that many moons ago (okay, it was over a decade ago, but who's counting!). It is staggering that I can shoot the same size photo with a tiny camera in my smartphone now.

12MP cameras will give you images that are plenty big enough to print from. When I exhibited the photos of my 365-day iPhone project, I was able to print many of them at 10 x 10-inch (25 x 25-cm) and 8 x 8-inch (20 x 20-cm) proportions, and they looked sharp and beautiful.

For printing purposes, you should have a resolution of 300ppi (pixels per inch) for a sharp, crisp print with excellent detail. I have been reliably informed by my friends (and experts in all things print-related) at Fotospeed, who undertook extensive tests, that you can drop your file down to 240ppi to give you a larger printable area and you will not be able to detect the loss of quality in the printed image. See page 136 for more about printing.

BACKING UP FILES

IT IS BRILLIANT TO BE ABLE TO SHOOT SO MANY PHOTOS WITH A DIGITAL CAMERA; THOSE DAYS OF SPARINGLY USING THE LIMITED SHOTS ON YOUR FILM ROLL ARE LONG GONE FOR MOST PEOPLE.

However, with that ability to freely fire off photos comes a big responsibility: the ever-present need to backup your treasures somewhere safe and sound. I can't stress enough how important it is to backup your photos and store them somewhere other than on your phone, because your smartphone camera roll is just not big enough for the job. It would be terrible to lose your device and with it your collection of visual gems and family memories. So whether you choose to use cloud storage or stick with external hard drives for storing your work, just do something, and do it often. Be proactive about moving your images to your safe place and you will never have that annoying "storage full" message again just when you are about to take your greatest photograph!

Many people go for the cloud option. For those of you that are unfamiliar with saving to cloud, it is basically paying for space on an online server. Uploading everything to that server will keep your files safe from harm and off-site in case of flood or fire. It is worth considering a local backup option too. I have a cloud backup, and I backup all my files to local external hard drives, and then I make copies of those drives so that I have three copies of everything. This may sound like a belt-and-braces approach, but I do this because I have experienced the pain and distress of a backup hard drive dying on me. I learned the hard way that drives are fallible and now I backup the backup drive too so that I don't ever have to experience that agony ever again!

JPEG, TIFF, AND RAW FILE FORMATS

PHOTOGRAPHIC FILE FORMATS ARE DIVIDED INTO TWO DIFFERENT CATEGORIES: "LOSSY" AND "LOSSLESS." THESE CATEGORIES DESCRIBE THE WAY THAT FILES ARE COMPRESSED AND WHETHER THEY INCLUDE ALL OF A FILE'S ORIGINAL DATA.

JPEG You may have noticed that if you look at the digital files for your photos, they have a filename that ends in .jpg. This is an abbreviation of JPEG, a file format that smartphones use automatically to save your photographs. JPEGs are generally best for files that are going to need to be small enough to load quickly on websites and will mainly just be viewed on screens. These are often saved with a resolution of 72dpi (dots per inch), which is the standard resolution for viewing images on a screen.

JPEGs are a lossy format, and as such are designed with file size rather than quality as their foremost function. When a photograph is taken, it is full of useful data about the color and tone contained within its pixels (image data). When it is saved as a JPEG, the data is compressed into a small package, which means that some of the image data is basically excluded during the saving process to keep the files nice and small.

The next time the picture is opened, the lost data is not restored, meaning that compression artefacts may already be appearing in the file. This means that the image is already of a poorer quality than when you started. The next time the image is altered or saved before it is closed again, more data will be lost to keep the file size small, and so over time the image quality will continue to degrade. Clearly this is not ideal. But saving the files as the biggest and highest quality JPEG possible will go some way to alleviating issues of compression.

If you are interested in preserving optimum image quality, then you may want to consider TIFF or RAW file-saving formats, but be warned: these monster-sized files will fill up your storage space in no time, so make sure to read my notes on backing up on the opposite page. This will help prevent you being bogged down with files and missing an opportunity to take a photo because you have run out of storage space.

TIFF The TIFF compression format for file saving is your best bet for keeping your photo quality intact. TIFFs provide lossless compression, so all the data is retained and available in the file, thus making the files substantially larger. Apps like ProCamera for iPhone and the Android's Pro Mode allow you to shoot in TIFF format. As TIFF files are much larger in size than JPEGs, they may be overkill for some photographers. You will need to decide what works best for you.

RAW The gold standard of file saving is RAW. The first smartphones and apps with RAW shooting capability are arriving on the market now, which heralds a new dawn in the timeline of smartphone photography. The future has arrived! RAW files are sometimes referred to as digital negatives, so when devices save the files in this format they either call them RAW or DNG files. RAW photos have a lot more scope for editing later on, with the ability to make a wider range of corrections to exposure, noise, and white balance in a non-destructive way. As you can imagine, these are large files and will take up a lot of disk space to store and backup.

KIT LIST

HERE IS A LIST OF THE KIT THAT I USED
TO MAKE THE IMAGES IN THIS BOOK.

TRIPODS

- Joby GorillaPod flexible tripod with a Joby GripTight Mount PRO Phone head

- Manfrotto 190X ProB Tripod and a Manfrotto 3-way magnesium head

LENSES

- Olloclip Macro Pro Lens set with 7x, 14x, and 21x magnification options

- Olloclip Active Lens set with an ultra-wide and a 2x telephoto option

BATTERY CHARGERS AND STORAGE

- RAVPower 6-in-1 NAS FileHub and 6000 mAh internal battery charger

- RAVPower iSmart Deluxe charging bank

primarily use the 6-in-1 as a battery backup with ts USB lead for charging on-the-go when I run out of juice, which happens often in bright light when have the screen on full brightness. It is also a data storage device, which I use with a 64GB micro SD card. It also allows you to transfer data wirelessly while you are on the move. It acts as a NAS file hub too. It costs very little, weighs next to nothing, and fits into my pocket comfortably, so it is always with me.

The iSmart charging bank has a 16750 mAh capacity and can fast-charge simultaneously from 2 USB ports, so my devices never run out of juice.

REFLECTORS AND DIFFUSERS

I have a range of homemade reflectors and diffusers, and I carry a roll of aluminum foil and a little sheet of white muslin (cheesecloth) with some pegs and clips, which makes a great window light diffuser; it folds very small, weighs nothing, and fits in the bottom of my tripod bag. I also own a range of reflectors, light boxes, and diffusers from the Lastolite Professional Range, which I primarily use for portraits and still-life photos.

UPLOADING IMAGES

The PhotoSync image transfer app is my preferred method for rapidly uploading images from my devices to my computer or the cloud for backing up. It works in various ways, including wirelessly, and will sync to cloud too for a small extra cost. It works very quickly and only updates the images that are new, saving me time and headspace in this otherwise boring but necessary admin task.

OTHER ESSENTIALS

I always carry a basic set of essentials such as spare charging leads, a car charger, a lens cloth, and a plastic zip-lock bag for keeping things dry and clean. I go through gallons of EcoMoist lens cleaner which is biodegradable, hypoallergenic, naturally antibacterial, and not tested on animals, so it keeps all of my glass smear-free and in great shape.

I also have some cheap generic items:
- Ring flash

- Bluetooth wireless remote shutter trigger

INDEX

ACKNOWLEDGMENTS

Thanks to everyone at CICO, especially to Pete Jorgensen for guiding me with great skill, patience and kindness. Also to David Peters and Cindy Richards for finding me and giving me this opportunity. And to my literary agent, Jane Turnbull, for your expertise and belief in the book.

Enormous thanks to Jason Risorto for generously giving up your time and locations in New York. And to Ben Rutherford for the many hours spent helping me with the image selection.

Huge thanks to Brooke Ewen for your good grace and patience. And to Alisha Vestal, Amanda Sorenson, Hash Halper, Ivy Bogart, Saina Khvan, and Samantha Oyeniyi for agreeing to do street portraits in the extreme heat of the NYC summer.

Thanks to Charlie Collyer, for magical baskets brimming with props, and Will Lamerton for Tor hopping and painting fruit.

Thanks to Toby Herlinger and all at Fotospeed for your kind support for all things printing. Also to Fiona Bull at Hope and Glory PR and all at HTC for the use of the fabulous HTC U11 smartphone.

Thank you Paul, Grace, and Kade you inspire me to be the best version of me I can possibly be. Love and thanks also to my mum, Carol, for unfaltering belief in me and for helping with the kids while I wrote the book. And to my dad, David, for gifting me an early interest in photography and for your pride in everything I do.

Thanks also to Nigel Hunter and Jackie Bradford for your quiet support in more ways than I can mention.

To my lovely friends old and new for the early morning runs, child care, food, wine and laughter while I wrote this book.

And last but by no means least, thanks to everyone who follows my photography on Instagram, your support and friendship has been immeasurably important to me, and without you I would never have had this wonderful opportunity. I hope that you all find this book as enjoyable an experience to read as it was to make.